Crafting CUTE

Polymer Clay the Kawaii Way

50 Fantastically Fun Projects

ROCK POINT

FUNUSUAL SUSPECTS

Dani Banani

Dani Banani
of Funusual Suspects

Brimming with creative inspiration, how-to projects, and useful information to enrich your everyday life, Quarto Knows is a favorite destination for those pursuing their interests and passions. Visit our site and dig deeper with our books into your area of interest: Quarto Creates, Quarto Cooks, Quarto Homes, Quarto Lives, Quarto Drives, Quarto Explores, Quarto Gifts, or Quarto Kids.

First published in 2019 by Rock Point, an imprint of The Quarto Group, 142 West 36th Street, 4th Floor, New York, NY 10018, USA
T (212) 779-4972 F (212) 779-6058 www.QuartoKnows.com

Rock Point titles are also available at discount for retail, wholesale, promotional and bulk purchase. For details, contact the Special Sales Manager by email at specialsales@quarto.com or by mail at The Quarto Group, Attn: Special Sales Manager, 100 Cummings Center Suite, 265D, Beverly, MA 01915, USA.

10 9 8 7 6 5 4 3 2

ISBN: 978-1-63106-631-3

Library of Congress Cataloging-in-Publication Data

Names: Banani, Dani, author.
Title: Crafting cute : polymer clay the Kawaii way / Dani Banani.
Description: New York, NY : Rock Point, 2019.
Identifiers: LCCN 2019028159 (print) | LCCN 2019028160 (ebook) | ISBN
 9781631066313 (paperback) | ISBN 9780760365694 (ebook)
Subjects: LCSH: Polymer clay craft. | Miniature craft.
Classification: LCC TT297 .B356 2019 (print) | LCC TT297 (ebook) | DDC
 745.57/23—dc23
LC record available at https://lccn.loc.gov/2019028159
LC ebook record available at https://lccn.loc.gov/2019028160

Publisher: Rage Kindelsperger
Creative Director: Laura Drew
Managing Editor: Cara Donaldson
Senior Editor: Erin Canning
Art Director: Cindy Samargia Laun
Cover Design: Emily Weigel
Interior Design: Diana Boger
Photography: Mary Ellen Williamson

Printed in China TT092020

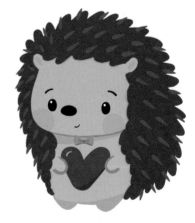

This book is for all the makers, artists, and crafters out there, who are committed to a lifelong journey of exploration, discovery, and creativity. Thank you for bringing a little more beauty into this world.

Contents

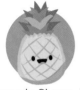
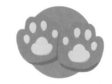
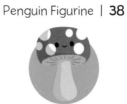

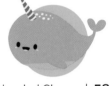
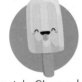
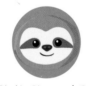
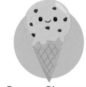
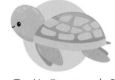
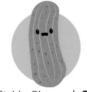
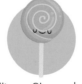

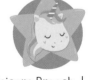
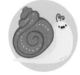
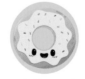
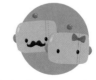
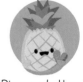

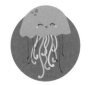
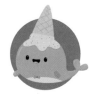

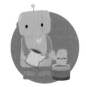
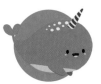
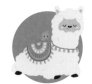

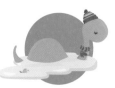

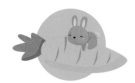

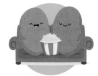
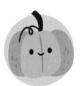
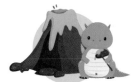
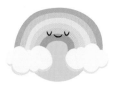

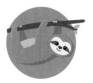
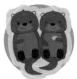
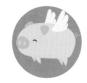
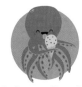
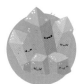

Introduction

Hi! I'm Dani, the artist and crafter behind the polymer-clay projects you're about to dive into. My friends call me Banani, and since I hope we'll be friends by the end of this book, you should call me that too.

Actually, anyone who is interested in art, crafting, and handmade hobbies, is a friend of mine. I grew up in Nebraska, but I've lived and worked in and around Seattle for more than a decade. I've always doodled, sketched, and drawn ever since I was a little girl, and it was always my dream to be able to make art when I grew up. Well, after moving west, and taking a series of retail jobs, I finally managed to break into commercial digital graphics work, which was fun, helping me to refine my style and speed up my process. But, as much as I enjoyed that, I still longed to work on my own art, my own concepts.

HOW I BECAME A POLYMER-CLAY ARTIST

I kept drawing and sketching, and then in the spring of 2015, I saw some polymer clay in a craft store. I had no idea how to work with it or what I could do, but I decided to give it a try. After a few hours of playing and experimenting, I was hooked! It was everything I wanted in a hobby: it's creative, quick and easy to learn, results oriented, inexpensive, and adaptable to virtually any style. So, I started making cute, little charms based on some of my doodles and characters. And in a few weeks later, I was getting requests for custom pieces! (OK . . . it was my mom, but still!)

I experimented with different styles and techniques, some that I made up myself and some I found via online videos or short tutorials about various aspects of polymer-clay crafting. Months of trial and error followed, as I learned what works, and what doesn't. After some encouragement from friends and family, I decided to offer my items for sale online through an Etsy shop. For the first few months, I had some polite interest in a few of my pieces. Then, in early 2016, I made a small sloth air plant holder that people really liked. He was cute and cuddly and hugging a tiny plant in his arms (the air plant was a *Tillandsia*, which doesn't require soil). It struck a chord with people, and suddenly I was getting requests for all kinds of cute critters, done in my particular *kawaii* style (see page 8 to learn more about this).

My husband, Trevor, and I are always making silly puns and jokes, so those have become a key feature of many of my designs, including visual puns in my clay projects. Fast forward a few years, and now managing my online shop, FunusualSuspects.com, and making cute clay objects have become my full-time job. In fact, our little operation has even expanded to include a CEO (Cat Executive Officer named Morrie) and a Head of Security (our dog, Absa)!

HOW TO USE THIS BOOK

The projects in this book are designed around all the things that I love about polymer-clay crafting: they are easy and inexpensive to make, along with being cute and colorful! I created simple, quick, and small projects to get you started, and then building upon that solid foundation, I show you how to make more complex designs. I hope there is something in here for everyone, at every skill and experience level, but these projects are especially geared

toward those looking for a quick and easy entry point into the world of polymer-clay crafting. With a very small investment in time, tools, and materials, you should be able to create something unique, cute, and useful, which you'll be proud to give to friends or show off on your desk.

The projects are broken down into three categories: twenty-five small projects (20 to 30 minutes) on pages 42 to 63, fifteen midsize projects (30 to 60 minutes) on pages 64 to 105, and ten show-stopper projects (60 to 90 minutes+) on pages 106 to 142. The techniques and skills you learn in the early projects will be very helpful in the later ones, but you don't necessarily have to go through this book in any order. Feel free to find a project that really speaks to you and makes you excited (and maybe even a little scared) to try it. Go for it! You've got this, and I'll be right here to help. You

can always refer to an earlier project if you need to pick up a skill to finish a more complex one. Take your time, be patient, and remember: practice makes perfect. If you aren't happy with the result, you can always smush the clay all up and start over again as long as you haven't baked it yet.

Thanks for coming along with me on this cute and crafty adventure in *Crafting Cute*. I have kept things fun, fresh, and fast, because I know your time is precious and I want to make the most of it. If you get stuck or have questions, reach out on Facebook, Twitter, or Instagram (@funusualsuspects), and I'll do my best to help. And make sure you share your creations with me! I'd love to see photos of all your projects.

OK, are you ready to have some fun and make some cute stuff?! Then let's get started!

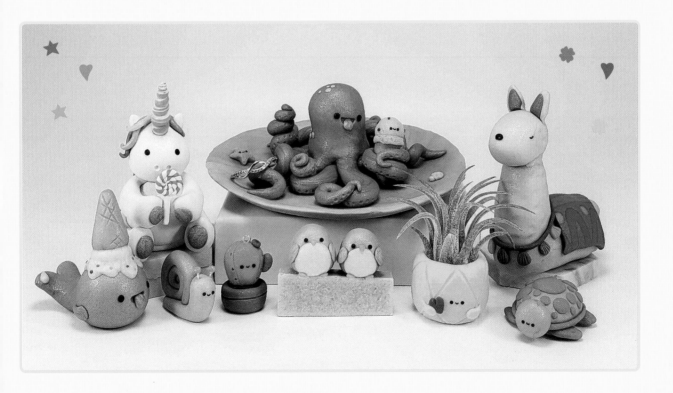

What Is Kawaii?

Kawaii, which means "cute" in Japanese, is an illustration style first made popular in Japan but has since gained a worldwide following. It's everywhere now, so you probably have seen this style of anthropomorphizing everyday objects by putting cute, expressive faces on them, along with the adorable *chibi* style of character design that transforms animals and people into ultra-cute childlike figures.

I was drawn to this style of art (pun intended) because of the way it's used to create an instant emotional response in the viewer. People automatically have an "awww!" moment when they see this kind of cuteness, and I wanted that kind of reaction to my work. My goal is to bring a little more joy into the world, and kawaii is a simple, elegant way to do that.

Making kawaii art might seem easy and simple, but it does take some thought and planning in the case of polymer-clay crafting. "Cuteness" is subjective, so what might seem adorable to one person may fall flat with another. You have to find the right balance between being delicate and subtle and bold and broad. The creation of the face with black clay in most of the designs gives you a lot of room to make them unique to you. You can play around with the spacing, the size, the placement, the angle—all of it can make a difference in the overall effect. And remember, after it's baked, it's a finished piece, so take the time you need to get it right before it goes into the oven.

The other reason I chose the kawaii style for this book is that it's a great way to start in polymer clay. Other styles might be more intricate, or require extra steps, like painting, but if you can make these projects, with just the simplest lines and curves, and make it cute, I think that gives you a great foundation on which to build whatever styles you may want to eventually branch out into.

Materials and Tools

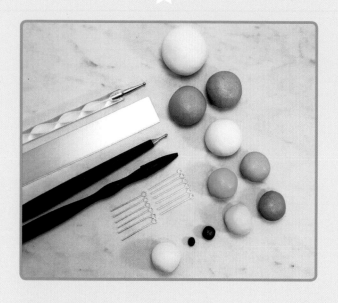

You don't need to have all these materials and tools on hand before you get started crafting with polymer clay. Start with just a few simple projects, and then grow your clay variety and toolset as you progress through the book. Go at your own pace, have fun, and experiment! Find out what materials and tools work best for you. There are no hard-and-fast rules here.

MATERIALS

These are the items you need to create your projects, and should be easy to find. They include the polymer clay, most importantly, along with eye pins for making charms, eye pin shafts for supporting pieces of the projects, earring backs, and more.

Polymer Clay: Polymer clay can be found in virtually any craft store and even many big-box retailers. You can also easily order it from many online vendors. There are a few different brands to choose from, but all of the projects in this book were made with Sculpey brand clay, so in the Materials list of each project, I list the name and number of the Sculpey clay being used. You are welcome to use another brand, but you may have to adjust conditioning (page 12), color mixing (page 13), and baking times (page 13) accordingly. All the polymer clay I've used in the projects in this book is in the low-to-mid price range, so you should be able to find something in your local area that will work for you. And, of course, the colors you use are completely up to you. For example, if you can't find a specific blue or brown clay, get creative and

change things up, and remember, you can always custom-mix your own colors by simply mixing two or more colors together.

Note: Polymer clay has been known to contain phthalates, giving it the potential to cause health problems, so look for brands that are phthalate-free. The clay I use is Polyform's Sculpey III brand, which falls under the phthalate-free formulas. Any phthalate-free clay should work identically to what I use, with some mild variations (i.e., softness, etc.) due to the unique formulas. For this purpose, every project has you start with conditioning the clay (page 12), which means working the polymer chains until they are pliable, warm, and ready to work. Some brands may take slightly longer to condition than others.

16-Gauge Round Wire: Commonly used in jewelry making, this wire is used in the projects in this book as a structural element to support larger pieces.

Brooch Clasp Backing: This backing with a pin on it is used for making brooches that can be attached to fabric.

Craft Glue: I prefer the E6000 brand or something similar. This glue is used to attach metal pieces, such as earring backs and brooch clasp backings, to the clay and to affix two or more pre-baked pieces of clay together to create a larger piece.

Earring Backs: These are used in the earring projects. I recommend using hypoallergenic, stainless-steel stems and push backs.

Eye Pin: Used in the charm projects, this metal pin has a loop, or eye, on the end that can be attached to a clasp or chain.

Eye Pin Shaft: An eye pin without the loop, the shaft is used as a structural element to hold large or more delicate pieces together.

Headpin: This metal pin has a flat head and is often used in jewelry making.

Liquid Sculpey: Available in Translucent and Pearl (both are called for in the projects here), Liquid Sculpey is a clear glaze that is used instead of craft glue to hold pieces together.

Additional Materials: There are other materials that you may need to complete some of the projects in this book, and I've done my best to make sure they are easy to find. Things such as string, paper clips, and air plants (*Tillandsia*) may be needed for decoration or for hanging a project.

TOOLS

The tools you'll need to use to complete the projects are also easy to come by and can usually be substituted for another alternative, if need be. They can be ordered online or found in most craft stores. These are the tools, you will find listed throughout the projects.

Ball Stylus: This long, tapered, handheld tool ends in a round, stainless-steel ball and is used for making indentations in the clay and affixing pieces to one another. There are three sizes called for in this book: small (1/16 inch, or 2 mm), medium (7/32 inch, or 6 mm), and large (7/16 inch, or 11 mm).

Chisel Tip Shaper: This long, tapered, handheld tool with has a wedge tip and is used to make notches and textured patterns in the clay.

Circle Cutter: This works just like a cookie cutter and is great for making perfect circles in clay. There are two sizes of the circle cutter used in these projects: small (1¼ inches, or 3 cm) and medium (1½ inches, or 4 cm).

Craft Blade or Knife: An X-acto blade or similar razor-edged knife is useful for cutting clean edges in the clay. Make sure to protect any surfaces you're cutting on, as well as your fingers.

Curved Carving Tool: This long, tapered, handheld tool has a curved, half-moon shaped blade that is useful for carving mouths in the projects.

Diamond Tip Tool: This long, tapered, handheld tool has a diamond-shaped tip that is great for creating textured patterns in clay.

Long eye pin: A longer version of the eye pin (left) that is 2 inches (5 cm) long and is used for making lines and patterns in the clay.

Metal brush: This small, handheld tool with a metal wire brush tip is used for creating textured patterns in clay.

Needle tool: This long, tapered, handheld tool has a thin spike at the end and is used for creating patterns and indentations in the clay.

Roller: This long, round dowel, about 2 inches (5 cm) in diameter and 12 inches (30 cm) in length can be made of smooth wood, glass, plastic, or marble, and is used for rolling out flat pieces of clay.

Star-Shaped Cutter: This works just like a cookie cutter and is great for making perfect stars in clay. The size I recommend for the projects here is 1¾ inches (4.5 cm) at its widest point.

Toothbrush: A regular toothbrush can be used (designate one for clay only) to make textures and fine details in the clay.

Additional Tools: In a couple of projects, you will come across tools, such as needle-nose pliers and a small square-head (Robertson) screwdriver or drill bit. These are things that you should most likely already have on hand in a toolbox.

How to Work with Polymer Clay

Through trial and error, I have discovered that polymer clay is not particularly suited for making large or functional pieces (e.g., plates, bowls, and cups). It is perfect for making small, decorative items, such as jewelry and ornaments. And, after it's baked and cured, it's also virtually waterproof, so pieces can be used in a variety of interesting environments, such as kitchens and bathrooms, and in unique ways, like for plant holders. I share more tips and tricks like these throughout the projects in this book, in an effort to give you a few shortcuts here and there along your way to cute clay crafts. Here's how to work with polymer clay for best results.

CONDITIONING THE CLAY

There is an important first step that you'll need to follow when working with polymer clay: you must condition your clay before getting started on each project. What is "conditioning"? I'm glad you asked. Well, the polymers in polymer clay are long molecular chains that give it the pliability and strength needed to attain and hold a smooth shape. These long chains are activated and made better and stronger if the clay is first kneaded and warmed up before trying to sculpt or mold it. This means working the clay between the heels of your hands, stretching and kneading it, until it's smooth and slightly warmed. This will not only make it much easier to use, but it will also produce better results too. Using clay that has not been conditioned doesn't bake evenly, can be crumbly, and can be more prone to cracking or breaking afterward.

MEASURING OUT THE CLAY

Measuring out the amount of clay you need for each part of a project can be difficult without a digital scale, and even then, it can be tricky for some of the very small accent pieces. So, instead of measuring in weight, I refer to the sizes of the raw clay needed for each project as in the photo below:

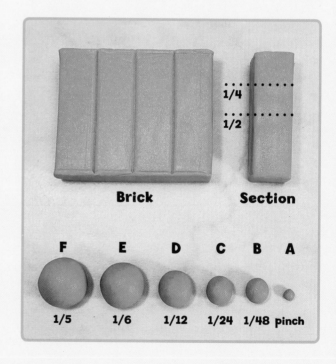

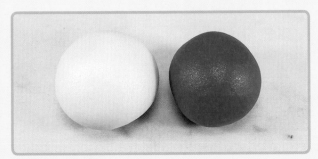

Conditioned clay.

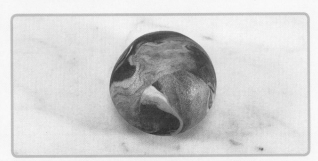

Two colors lightly mixed together to create a marbled effect.

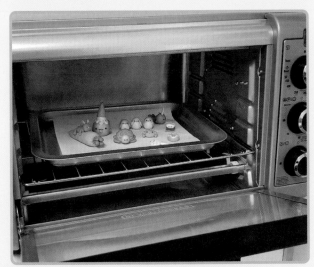

Time to bake!

Once you condition clay, you should then roll your clay into balls like in the photo. None of the projects are dependent on ultra-precise measurements, so you should be able to estimate just fine. Just be consistent throughout and it should all work out. If you want to make any of the projects slightly smaller or larger, just scale down or up accordingly. Also, you'll need to adjust the baking times depending on how much difference there is from the original project.

MIXING COLORS

One of the great things about polymer clay is that you can mix colors together (as long as you're using the same brand/quality/type). Need your pink to be a little bit lighter? No problem. Just pinch off a small piece of pearl or white clay and knead it into your pink piece until the color is uniform throughout. You can also only lightly knead colors together to create different patterns and effects, such as the marbling effect in the photos (left). When in doubt, try a few test pieces first to make sure you have the right color ratios before mixing larger amounts of clay together.

BAKING AND CURING

Unless otherwise noted, the standard baking temperature is 275°F (135°C). This temperature ensures the clay bakes slowly enough to set properly and not crack as easily. Watch your projects when they bake, as ovens, and other conditions, can vary widely. The baking times listed are approximate only, so remove your items from the oven before they begin to discolor or brown (unless you want that effect). Make sure to allow your pieces to cool completely before use as they require this curing time to securely set the polymer clay.

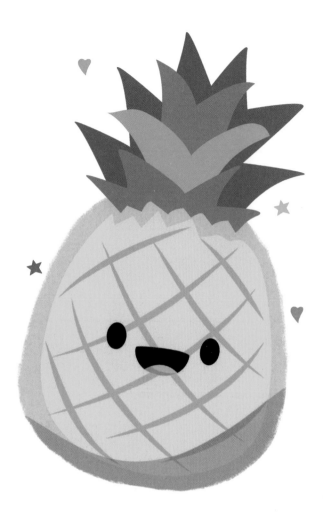

Pineapple Charm

This sweet little charm is a perfect first polymer-clay project because it's easy, quick, colorful, and bright! Here are all the little tidbits you need to know. Let's get started!

Project time: 15 to 20 minutes

MATERIALS

Body: 1 E-size piece Yellow (Sculpey #072)

Crown: 1 D-size piece Green (Sculpey #322)

Face: 1 A-size piece Black (Sculpey #042)

½-inch-long (13 mm) eye pin

TOOLS

Long eye pin

Chisel tip shaper

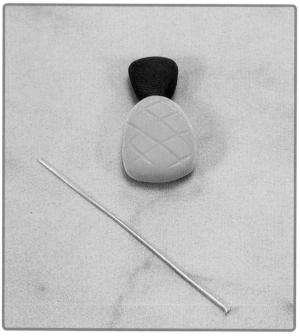

1. Condition your clay to make sure it's pliable and ready to work (see page 12). Roll each piece into a ball. Shape the yellow ball into the body by tapering the top slightly and rounding the bottom after pressing it slightly flat. Shape the green ball into the crown by tapering the bottom slightly and rounding the top, again after pressing it slightly flat, to match the same thickness as the body you made. Attach the crown to the body by pushing them together gently. Use the eye pin to create a crisscross pattern on the body.

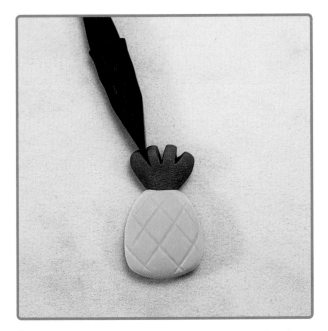

2. Use your chisel tip shaper to create small indents in the crown to simulate spiky leaves.

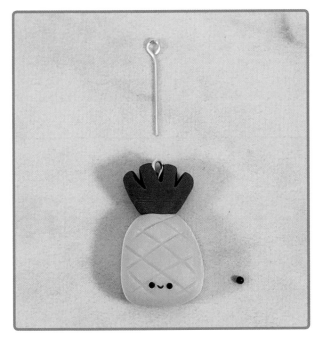

3. Use the black clay to create a line for the mouth and two small disks for eyes. Gently but firmly apply the face to the body at your desired location. Insert the eye pin through the top of the charm, making sure to connect the crown to the body. Be gentle so you don't bend the fresh spikes you made on top.

VARIATIONS

• Make two pineapple charms for earrings.

• Create taller and more intricate crowns.

• Change the facial expressions, or make the pineapples without faces.

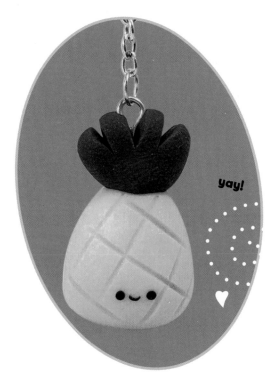

yay!

4. Bake the charm at 275°F (135°C) for about 10 minutes. Keep an eye on it near the end to make sure the yellow clay doesn't discolor. Allow to cool completely.

Pineapple Charm • 15

Pig Charm

This petite porker is the perfect project to practice your polymer-clay skills. You'll be bringing home the bacon in no time!

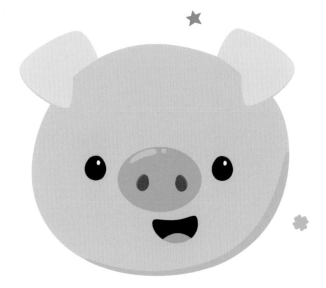

Project time: 20 minutes

MATERIALS
Head: 1 F-size piece Ballerina Pink (Sculpey #1209)
Eyes: 1 A-size piece Black (Sculpey #042)
½-inch-long (13 mm) eye pin
TOOLS
Small ball stylus

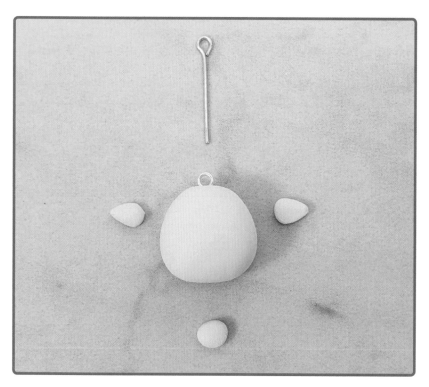

1. Condition your clay to make sure it's pliable and ready to work (see page 12). Roll each piece into a ball. Pinch off a small piece from the pink ball and divide it into three pieces. Shape one piece into a ball for the snout and the remaining two pieces into rounded triangles for ears. Shape the remaining pink ball into the head. Carefully insert your charm eye pin in the top of the head.

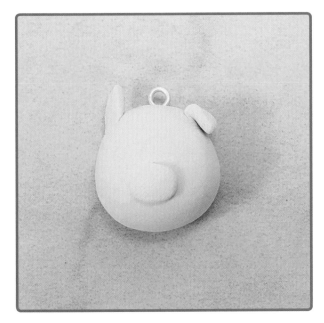

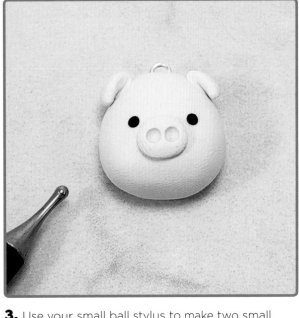

2. Do the final shaping of the snout and ears, and gently but firmly press them into place on the head at your desired location.

3. Use your small ball stylus to make two small indentations on the pig's snout to create the nostrils. Divide the black clay in half, and create small disks for the eyes. Press the eyes on gently, so as to not distort the face shape.

4. Bake the charm at 275°F (135°C) for about 10 minutes. Keep an eye on it to make sure the pink clay doesn't discolor. Allow to cool completely.

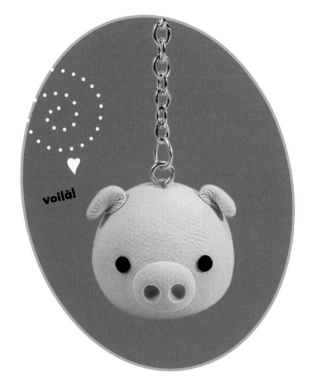

voilà!

VARIATIONS

- Make a pair for earrings.
- Change the ear shape and position to make your pig quirkier.
- Add a mouth to give it a smile.

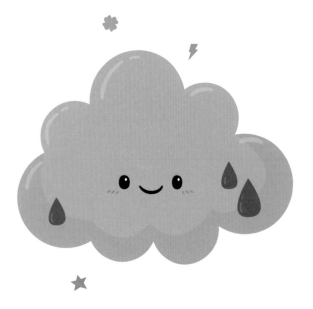

Cloud Charm

Looking for a quick project for a rainy day? Let's make a cute, little blue cloud out of clay!

Project time: 10 to 15 minutes

MATERIALS

Cloud: 1 F-size piece Light Blue Pearl (Sculpey #1103)

Raindrops: 1 B-size piece Light Blue Pearl (Sculpey #1103) completely mixed with 1 A-size piece Black (Sculpey #042)

Face: 1 A-size piece Black (Sculpey #042)

½-inch-long (13 mm) eye pin

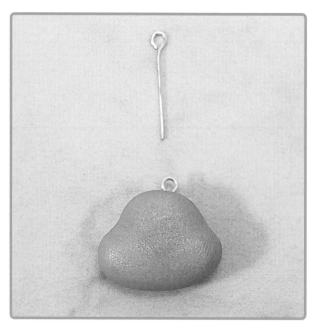

1. Condition your clay to make sure it's pliable and ready to work (see page 12). Roll each piece into a ball. Form the light blue ball into a cloud shape, without making it too flat. Carefully insert your eye pin into the top of the cloud.

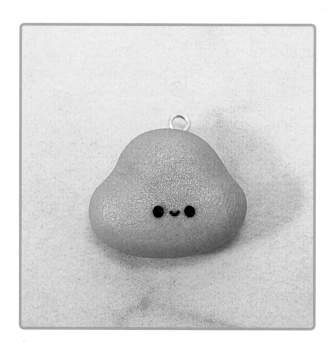

2. Do the final shaping and smoothing on the cloud. Use your black clay to create a small line for the mouth and two small disks for the eyes. Gently but firmly press them into place on the head at your desired location.

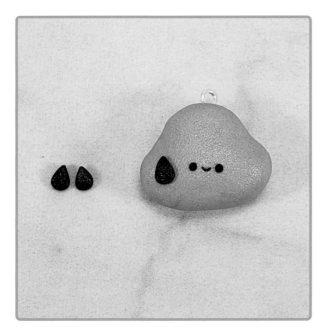

3. Divide your dark blue ball into three small pieces of varying sizes and shape them into teardrops. Press the drops onto the cloud, being careful not to deform either the cloud or the raindrops.

ta-da!

4. Bake the charm at 275°F (135°C) for about 15 minutes. Keep an eye on it to make sure the light blue clay doesn't discolor. Allow to cool completely.

VARIATIONS

• Make white or gray clouds.

• Add a small yellow lightning bolt.

• Make the clouds slightly smaller and flatter to create earrings.

• Change or omit the face.

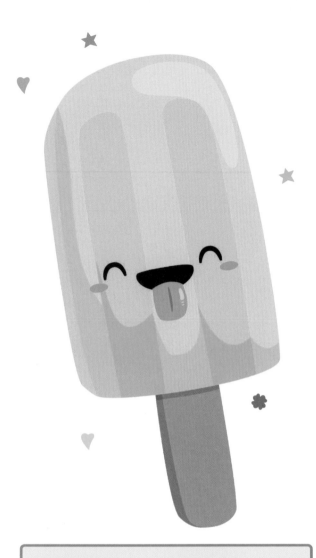

Popsicle Charm

This little charm is really easy to make and will have you looking super cool. If you stick with it, I promise you'll have a sweet treat afterward!

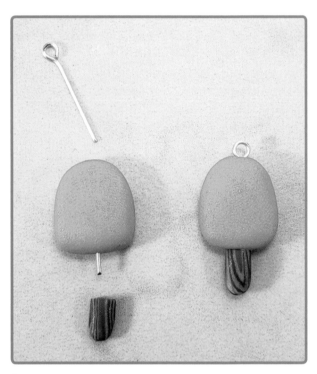

1. Condition your clay to make sure it's pliable and ready to work (see page 12), being careful not to overwork the "stick" piece of clay. Roll each piece into a ball. Shape the stick by creating an oblong shape, pressing it slightly flat, tapering the bottom, and blunting the top. Shape the orange ball into a slightly rounded rectangle, tapered at the top and more squared off on the bottom. Carefully insert your eye pin into the top of the orange piece, and insert the eye pin shaft into the bottom of the orange piece to connect it to your stick piece.

Project time: 15 minutes

MATERIALS

Popsicle: 1 E-size piece Sweet Potato (Sculpey #033) completely mixed with 1 B-size piece Pearl (Sculpey #1101)

Stick: 1 B-size piece Hazelnut (Sculpey #1657) lightly mixed with 1 B-size piece Jewelry Gold (Sculpey #1132) to create the swirled look of wood grain

Face: 1 A-size piece Black (Sculpey #042)

½-inch-long (13 mm) eye pin

¼-inch-long (6 mm) eye pin shaft, for support

TOOLS

Small ball stylus

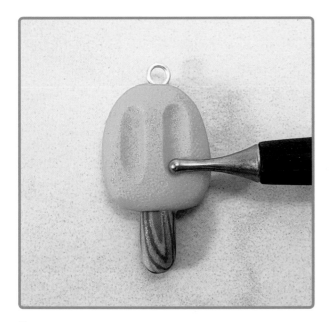

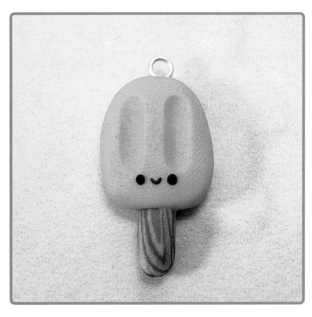

2. Do the final shaping and smoothing on the orange Popsicle. Use your small ball stylus to create two parallel indentations on the surface of both sides of the orange clay.

3. Use your black clay to create a small line for the mouth and two small disks for the eyes. Gently but firmly press them into place on the Popsicle at your desired location.

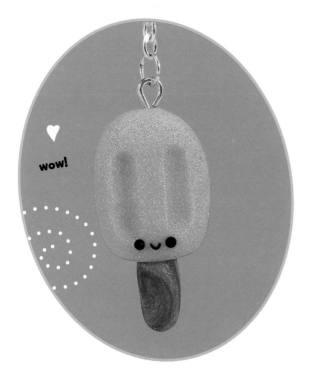

wow!

4. Bake the charm at 275°F (135°C) for about 15 minutes. Allow to cool completely.

VARIATIONS

- Change the colors! Grape, lime, and cherry are all classic Popsicle flavors.
- Make the Popsicles smaller and flatter for earrings.
- Change or omit the face or create an open-mouth look.
- Change the stick color.

Pickle Charm

Making this charm is really no big dill. In fact, it's easy being green! Let's get started and you won't be sour-ry!

Project time: 10 minutes

MATERIALS

Pickle: 1 E-size piece Leaf Green (Sculpey #322) completely mixed with 1 E-size piece Pearl (Sculpey #1101)

Face: 1 A-size piece Black (Sculpey #042)
½-inch-long (13 mm) eye pin

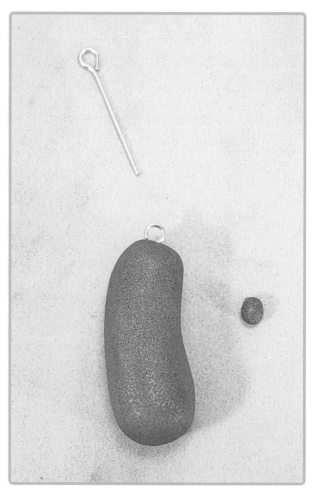

1. Condition your clay to make sure it's pliable and ready to work (see page 12). Roll each piece into a ball. Pinch off a small piece of the green ball and roll into a ball. Shape the remaining green ball into a pickle shape, tapering slightly at the ends. Carefully insert your eye pin into the top of the pickle.

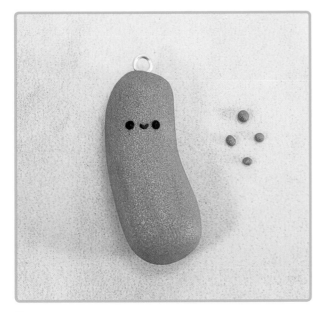

2. Do the final shaping and smoothing on the pickle body. Use your black clay to create a small line for the mouth and two disks for the eyes. Gently but firmly press them into place at your desired location. Divide your remaining green piece into a few small dots.

VARIATIONS

- Make smaller and flatter to create earrings.
- Change or omit the face or create an open-mouth look.
- Make a few pickles and place them in a jar for a cute look.
- Add a small clasp to create a stitch marker for knitting or crocheting.

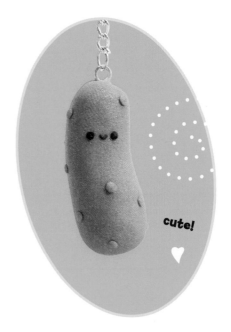

cute!

4. Bake the charm at 275°F (135°C) for 15 minutes. Allow to cool completely.

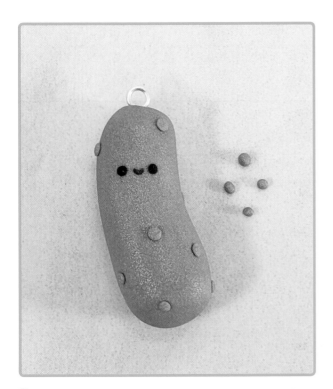

3. Place the green dots on the body to create the look and texture of a pickle.

Snail Figurine

Whoa! Slow down and enjoy this cute snail project. I've left you a clear trail to follow. Slime ready! Are you?

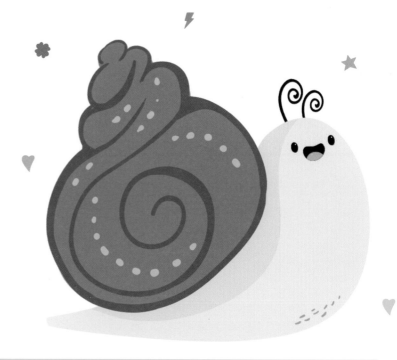

Project time: 15 minutes

MATERIALS

Shell: ½ section Fuchsia Pearl (Sculpey #1112) completely mixed with ½ section Pearl (Sculpey #1101)

Body: 1 E-size piece Jewelry Gold (Sculpey #1132) completely mixed with 1 E-size piece Pearl (Sculpey #1101)

Face: 1 A-size piece Black (Sculpey #042)

Two ¼-inch-long (6 mm) eye pin shafts, for the antennae

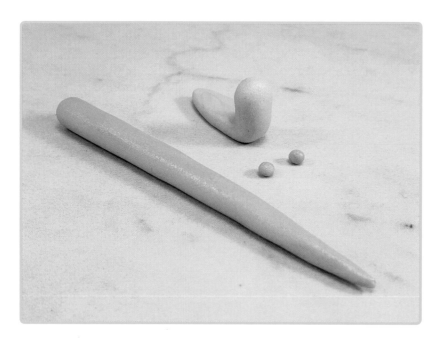

1. Condition your clay to make sure it's pliable and ready to work (see page 12). Roll each piece into a ball. Pinch off two small pieces of the pink ball for the antennae and roll into balls. Roll out the remaining pink ball into a long, tapered rod. Roll out the body piece into a shorter, tapered rod, and then flatten the thin end and bend the final third of the rod up 90 degrees to form the head and body.

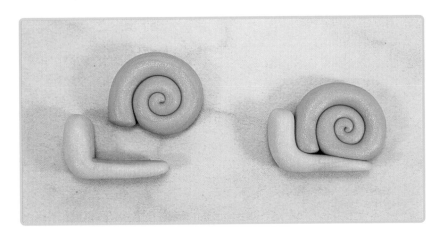

2. Starting with the tapered end, roll the pink rod up into a spiral. Attach the shell to the flattened bottom of the body segment.

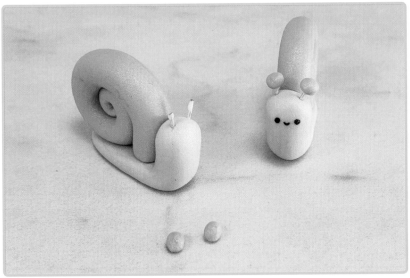

3. Place the two eye pin shafts in the top of the head. Add the two pink balls to the top of the eye pins to make the antenna. Use your black clay to create a small line for the mouth and two disks for eyes. Gently but firmly press them into place.

VARIATIONS

- Leave a tiny gap between the shell and body that you could fit a photograph or card into.
- Change the shell color.
- Add some freckles or body details.
- Add an open mouth.

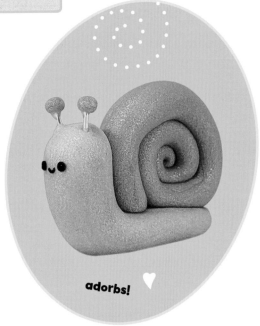

adorbs! ♥

4. Bake the figurine at 275°F (135°C) for 15 minutes. Allow to cool completely.

Cat Paws Earrings

If you are a fan of itty-bitty kitty-toe beans, this is the perfect project for you. You'll be feline just fine when we're done. Let's do it, just be claws.

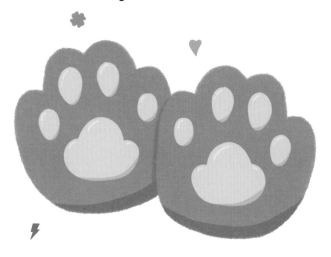

Project time: 15 minutes

MATERIALS

Paws: 1 D-size piece Elephant Gray (Sculpey #1645)

Foot pads: 1 C-size piece Ballerina Pink (Sculpey #1209)

2 earring backs

Craft glue (E6000 brand or similar)

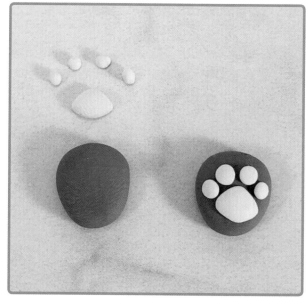

1. Condition your clay to make sure it's pliable and ready to work (see page 12). Roll each piece into a ball. Divide your gray ball in half. Shape each half into a rounded and slightly flattened disk.

2. Divide your pink ball into two B-size pieces and eight A-size balls. From the smaller balls, create slight teardrop shapes for the toe pads, and use the larger pieces to make the main foot-pad shapes, pressing each piece flat. Attach the pieces to the gray base, pressing gently but firmly.

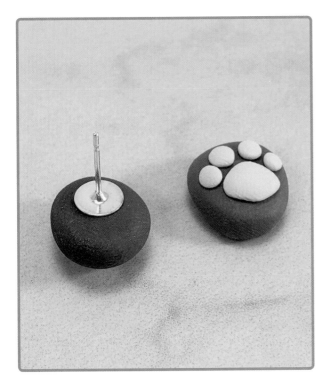

VARIATIONS

- Change the color of the paw to match your cat's coloring.
- Make small indents just above the pink toe pads to create claw beds.
- Make a larger piece as a charm or brooch.

3. Bake the earrings at 275°F (135°C) for 15 minutes. Allow to cool completely. Attach the earring backs using a drop of glue on the base of the earring back to create an extra-strong hold. Wipe away any excess.

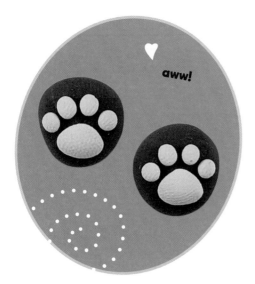

aww!

4. Allow the glue to cure for 24 hours before wearing the earrings.

Bacon & Egg Earrings

Don't tackle this project until you've had a full breakfast, or you'll get hungry halfway through. I'll be here to egg you on!

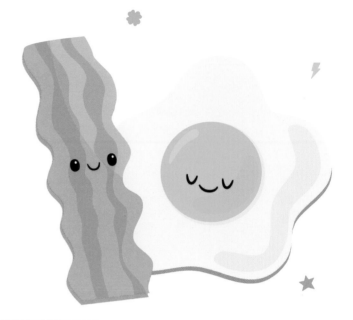

Project time: 20 minutes

MATERIALS

Egg white: 1 D-size piece White (Sculpey #001)

Egg yolk: 1 B-size piece Lemonade (Sculpey #1150)

Bacon: 1 C-size piece Deep Red Pearl (Sculpey #1140) and 1 C-size piece White (Sculpey #001)

Faces: 2 A-size pieces Black (Sculpey #042)

2 earring backs

Craft glue (E6000 brand or similar)

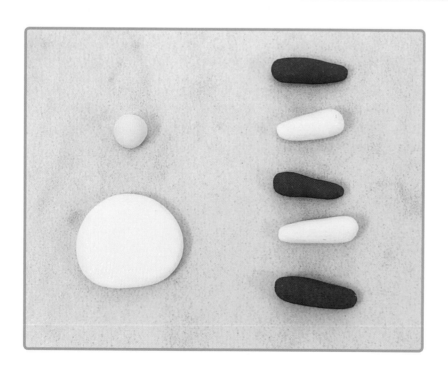

1. Condition your clay to make sure it's pliable and ready to work (see page 12). Roll each piece into a ball. Flatten the larger white ball to make a disk for the egg white. Make a small disk with the yellow ball for the yolk. Divide the red ball into three short strips, and the smaller white ball into two short strips, all about ½ inch (13 mm) long.

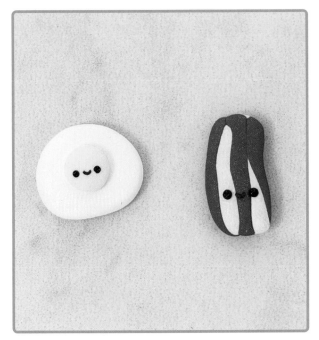

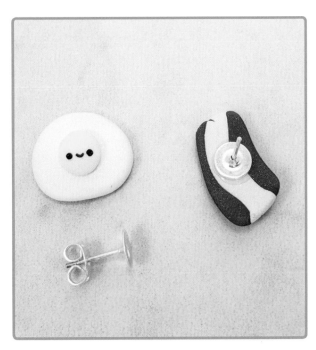

2. Place the yolk on the egg white, pressing down gently. Combine the red and white strips, pressing them together to form a single piece. Do not mix. Flatten the bacon piece slightly. Use your two small pinches of black clay to create two lines for the mouth and four small disks for the eyes. Gently but firmly press the eyes and mouth into place on each piece.

3. Bake the earrings at 275°F (135°C) for 15 minutes. Allow to cool completely. Attach the earring backs using a drop of glue on the base of the earring back to create an extra-strong hold. Wipe away any excess.

love!

VARIATIONS

- Combine the pieces to make a larger item such as a charm or brooch.
- Make two eggs or two strips of bacon instead of a mixed pair.
- Slightly fold the bacon edges to create a curled effect.

4. Allow the glue to cure for 24 hours before wearing the earrings.

Macaron Earrings

After you start wearing these super-sweet earrings, everyone will know what a smart cookie you are!

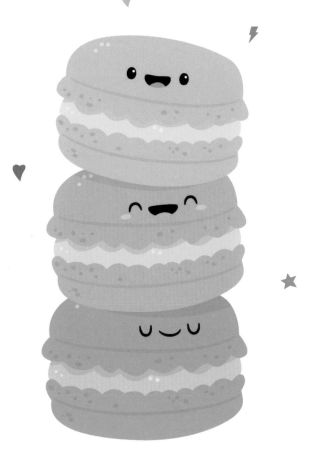

Project time: 20 minutes

MATERIALS

Cookie: 1 F-size piece Fuchsia Pearl (Sculpey #1112) completely mixed with 1 F-size piece Pearl (Sculpey #1101)

Filling: 1 B-size piece Fuchsia Pearl (Sculpey #1112) completely mixed with 1 C-size piece Pearl (Sculpey #1101)

Faces: 2 A-size pieces Black (Sculpey #042)

Two ¼-inch-long (6 mm) eye pins

2 earring clasps (fish hook wires or similar)

TOOLS

Metal brush

1. Condition your clay to make sure it's pliable and ready to work (see page 12). Roll each piece into a ball. Divide the dark pink ball into four equal-size pieces. Shape each into a ball, and then flatten the bottoms on your work surface, leaving the tops slightly rounded like a hamburger bun. Divide the lighter pink ball into two equal-size pieces, shape each into balls, and then flatten them into thin disks.

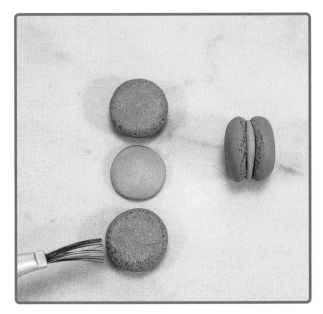

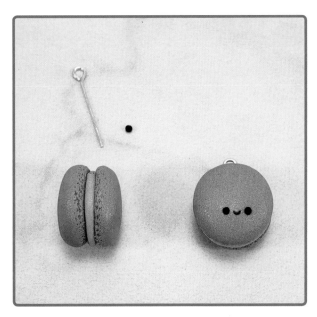

2. Use your metal brush to create a textured surface around the bases of the dark pink pieces. Carefully assemble the macaron by sandwiching the lighter pink filling between the dark pink cookies. Press the pieces gently but firmly to make sure they adhere.

3. Insert the eye pins into the tops of the assembled macarons, pressing them into the center filling. Use your black clay to create a small line for the mouth and two disks for the eyes, and place them where you think they look best.

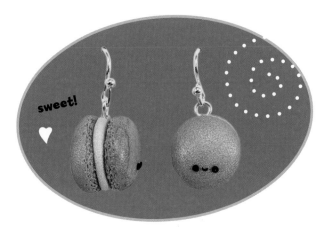

sweet! ♥

VARIATIONS

- Change up the colors of the cookies and fillings.
- Make a larger macaron as a brooch or charm.
- Make each one with a different facial expression.

4. Bake the earrings at 275°F (135°C) for 15 minutes. Allow to cool completely.

Sloth Charm

Typical of a sloth, this cute and soothing charm reminds you to slow down, hang out, and enjoy the moment. But this sloth will show up quickly if we start now!

Project time: 15 minutes

MATERIALS

Head and eye patches: 1 F-size piece Hazelnut (Sculpey #1657)

Face front: 1 D-size piece Jewelry Gold (Sculpey #1132)

Face details: 1 A-size piece Black (Sculpey #042)

½-inch-long (13 mm) eye pin

TOOLS

Long eye pin

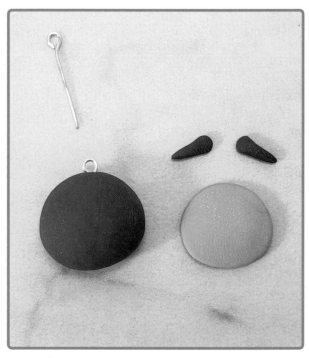

1. Condition your clay to make sure it's pliable and ready to work (see page 12). Roll each piece into a ball. Pinch off three small pieces from the brown ball and shape two of them into short strips slightly tapered at one end and roll the remaining one into a ball. Flatten all three of those pieces. Shape the remaining brown ball into a round head. Insert the eye pin into the top of the head. Flatten the gold ball into a flat disk that is slightly smaller than the head.

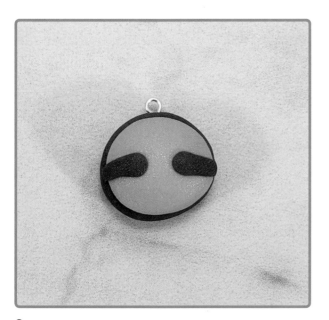

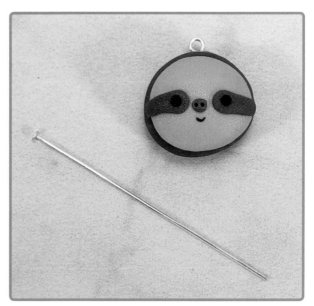

2. Press the gold disk onto the head, making sure they're attached. Add the two eye-patch strips, using the centered eye pin on top as a guide for placement.

3. Add the remaining small brown disk as the nose, placing it between the eye patches. Use the long eye pin to add the nostrils. Use your black clay to create a small line for the mouth and two disks for the eyes. Place the eye disks in the center of the eye patches and add the mouth line under the nose.

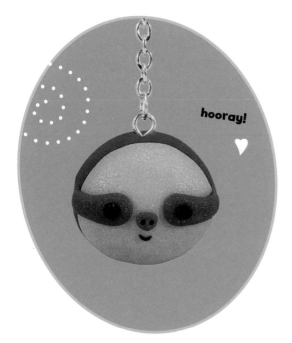

hooray!

VARIATIONS
- Make smaller and flatter versions as earrings.
- Make a larger one as a brooch.
- Change the facial expressions by varying the mouth shape, eye patch placement, or other features.

4. Bake the charm at 275°F (135°C) for 15 minutes. Allow to cool completely.

Lollipop Charm

This cute charm will make any outfit pop, and the process of making it is short and sweet. Once you master this sweet treat, check out the Unicorn Figurine on page 100.

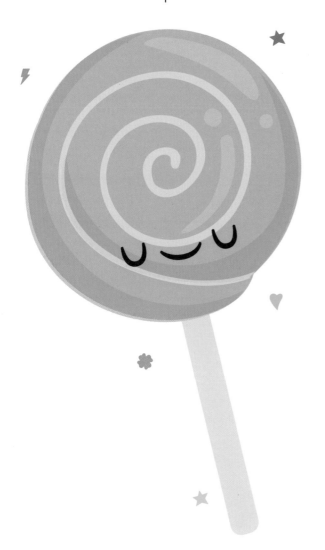

Unicorn Figurine on page 100.

Project time: 10 minutes

MATERIALS

Pink Swirl: 1 C-size piece Candy Pink (Sculpey #1142) completely mixed with 1 E-size piece White (Sculpey #001)

White Swirl: 1 E-size piece White (Sculpey #001) completely mixed with 1 E-size piece Pearl (Sculpey #1101)

Face: 1 A-size piece Black (Sculpey #042)

½-inch-long (13 mm) eye pin

½-inch-long (13 mm) eye pin shaft, for support

TOOLS

Craft blade or knife

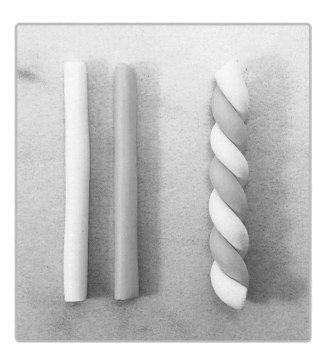

1. Condition your clay to make sure it's pliable and ready to work (see page 12). Roll each piece into a ball. Roll out each ball into strands, but don't make them very long just yet. Use your craft blade to trim a small piece of the white strand about ¾ inch (2 cm) long to make the lollipop stick in step 3. Make sure that the pink and white strands are about equal in length. Twist the two strands together to make a short length of "rope."

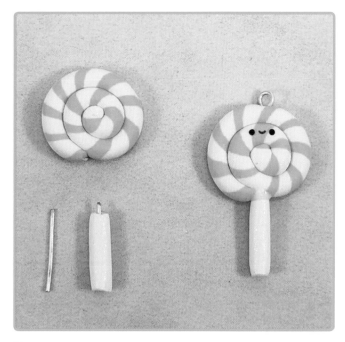

3. Roll up the strand to create a spiral shape. Flatten it very slightly on your work surface. Take the remaining strand of white clay and shape it into a small rod for the stick. Insert the eye pin into the top of the lollipop. Use the eye pin shaft to connect the lollipop to the stick. Use your black clay to create a small line for the mouth and two disks for the eyes, and place the face where you think it looks best.

2. Roll the rope into a long, smooth, and even strand, about 2 inches (5 cm) in length. Use your craft blade to trim the ends to square them off.

VARIATIONS

• Make smaller versions as earrings.

• Change the facial expression by varying the mouth shape and placement.

• Change the colors to create whatever "flavors" you like.

4. Bake the charm at 275°F (135°C) for 15 minutes. Keep an eye on it to make sure the white clay doesn't discolor too much. Allow to cool completely.

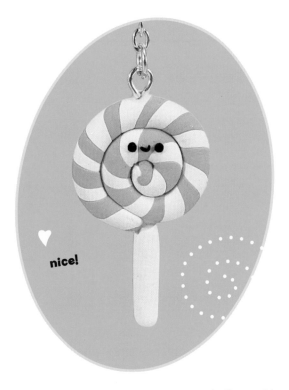

nice!

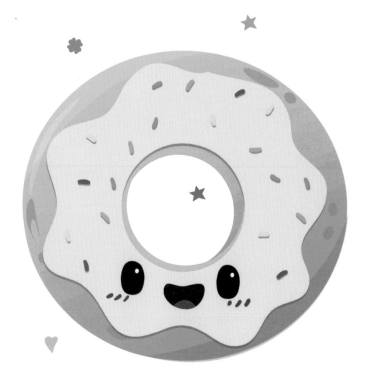

Donut Charm

This hole project is fun from start to finish. You'll be a-glazed at how easy it is!

Project time: 20 minutes

MATERIALS

Donut: 1 F-size piece Jewelry Gold (Sculpey #1132)

Sprinkles: Tiny pinches of whatever colors you prefer

Face: 1 A-size piece Black (Sculpey #042)

½-inch-long (13 mm) eye pin

Liquid Sculpey Pearl

TOOLS

Plastic straw

Needle tool

1. Condition your clay to make sure it's pliable and ready to work (see page 12). Roll each piece, including the sprinkles, into a ball. Slightly flatten the gold ball into a disk. Push the eye pin into the disk at a slight angle, and not directly through the center, so the eye pin isn't exposed. Use the straw to cut a hole out of the center of the donut. Smooth and round the surface.

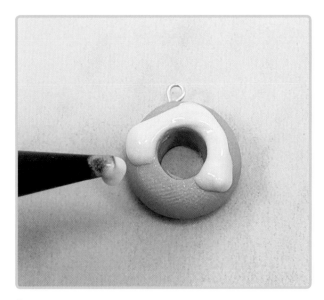

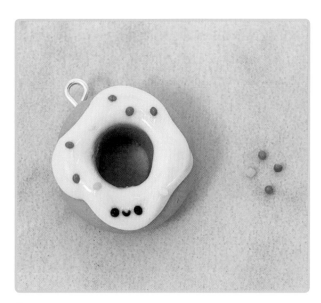

2. Carefully apply the Liquid Sculpey as a "glaze" to the top of the donut. A little goes a long way. Create the kind of glaze effect you want by adding a little more or less in certain areas.

3. Use your black clay to create a small line for the mouth and two disks for the eyes, and place them on the donut, opposite the eye pin. If desired, roll the small balls of sprinkles into rice shapes. Apply the sprinkles as you like, being careful to set the sprinkles gently into the glaze with your needle tool.

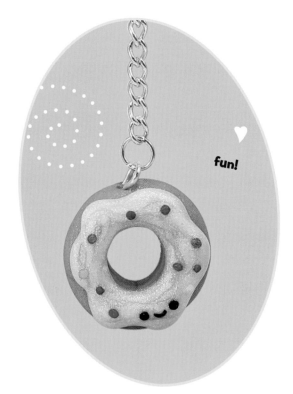

fun!

VARIATIONS

- Make smaller versions as earrings.
- Change the facial expressions by varying the mouth shape and placement.
- Change the color of the donut for different "flavors" or change the sprinkles.

4. Bake the charm at 275°F (135°C) for 15 minutes. Keep an eye on it to make sure the white glaze doesn't discolor too much. Allow to cool completely.

Penguin Figurine

You'll love making this widdle waddler so much that you'll want to make three of them! Let's get started.

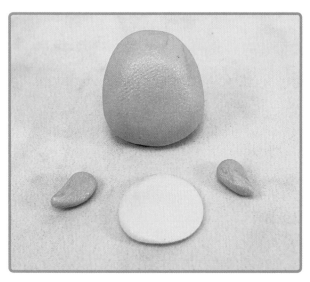

Project time: 20 minutes

MATERIALS

Body: 1 D-size piece Turquoise (Sculpey #505) completely mixed with 1 F-size piece Pearl (Sculpey #1101)

Tummy: 1 C-size piece Pearl (Sculpey #1101)

Beak and feet: 1 B-size piece Sweet Potato (Sculpey #033)

Eyes: 1 A-size piece Black (Sculpey #042)

1. Condition your clay to make sure it's pliable and ready to work (see page 12). Roll each piece into a ball. Pinch off two small pieces from the turquoise clay and form them into slight teardrop shapes to use as flippers in step 2. Shape the remaining turquoise ball into a smooth oval body, slightly pressing it down on your work surface to create a flat bottom. Flatten the white clay for the tummy so that it is slightly smaller than the turquoise body.

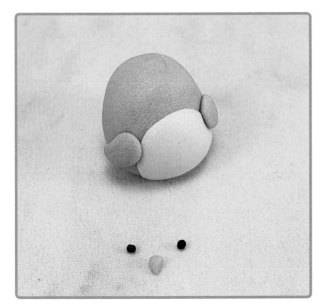

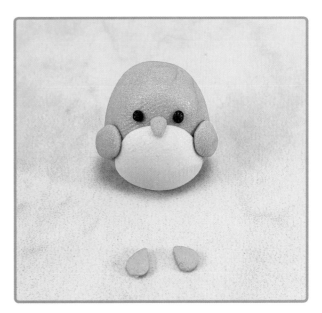

2. Attach the tummy to the front of the body, covering the lower two-thirds or so. Shape and add the two flippers to the sides, slightly overlapping the white tummy. Pinch off a small piece of orange clay and shape it into a rounded triangle for the beak, reserving the rest for the feet. Divide the black clay to create two small disks for the eyes.

3. Attach the beak and eyes. Divide the remaining orange clay in half, and make small triangular shapes with rounded edges for the feet. Tilt the penguin up slightly and attach the feet, making sure the figure still stands straight. Press the feet firmly into the base.

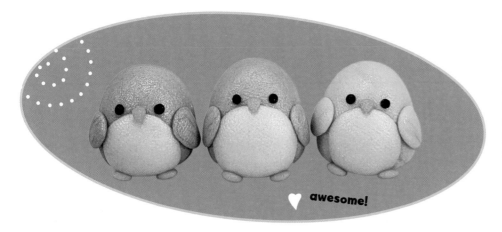

♥ *awesome!*

4. Bake the figurine at 275°F (135°C) for 15 minutes. Keep an eye on it to make sure the white clay doesn't discolor too much. Allow to cool completely.

VARIATIONS

• Change up the colors. Black and white are classic but challenging as the black clay tends to mess up the white clay if you aren't very careful.

• Change the beak size.

• Make an extra-tiny penguin to create a whole family.

Mushroom Charm

This cute, little forest dweller is easy and fun to make. Cap off a great day with a fungi!

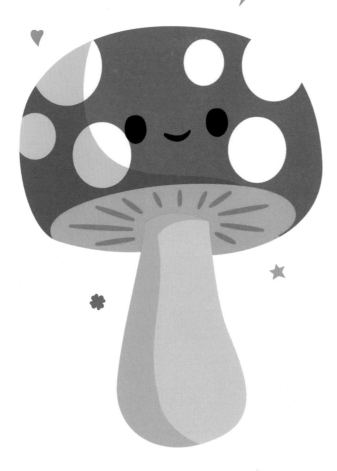

Project time: 20 minutes

MATERIALS

Stem: 1 D-size piece Jewelry Gold (Sculpey #1132) completely mixed with 1 D-size piece Pearl (Sculpey #1101)

Cap: 1 E-size piece Deep Red Pearl (Sculpey #1140)

Dots and gills: 1 C-size piece Pearl (Sculpey #1101)

Face: 1 A-size piece Black (Sculpey #042)

½-inch-long (13 mm) eye pin

TOOLS

Long eye pin

Medium ball stylus

1. Thoroughly mix and condition your clay to make sure it's pliable and ready to work (see page 12). Roll each piece into a ball. Pinch off a small piece from the white clay to use for the dots in step 3. Flatten the remaining white ball into a small disk. Shape the red ball into a slight cone with a flat bottom. Shape the stem piece also into a cone, but taller, slightly slimmer, and more tapered at the top. Press the stem onto your work surface to create a flat, stable base.

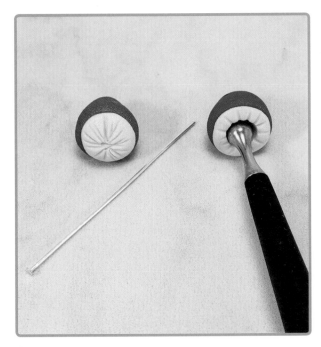

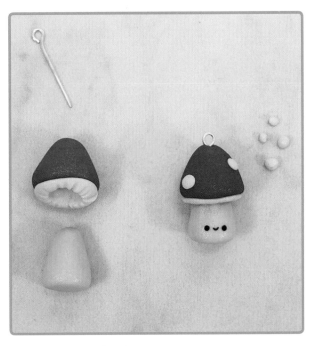

2. Press the white disk of clay onto the bottom of the red cone. Use the eye pin to create the lines for the gills on the underside of the mushroom. Use the medium ball stylus to create an indentation in the bottom of the red cap, through the white disk, for the stem to fit into.

3. Set the cap on top of the stem, making sure it's secure and stable. Make small disks from the remaining white clay and add them as dots on the red cap. Carefully insert the eye pin into the top of the cap. Use your black clay to create a small line for the mouth and two disks for the eyes. Put the face on the stem wherever you think it looks best.

VARIATIONS

- Make several mushrooms without faces and put them in and around your favorite houseplants.
- Change the colors of the stem or the cap.
- Change the facial expression or add an open mouth.
- Make smaller and flatter mushrooms as earrings.

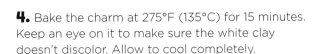

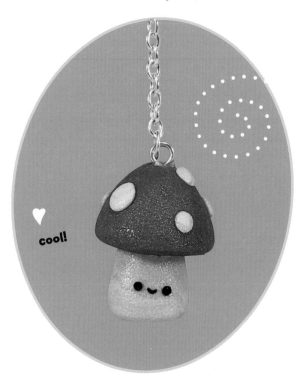

cool!

4. Bake the charm at 275°F (135°C) for 15 minutes. Keep an eye on it to make sure the white clay doesn't discolor. Allow to cool completely.

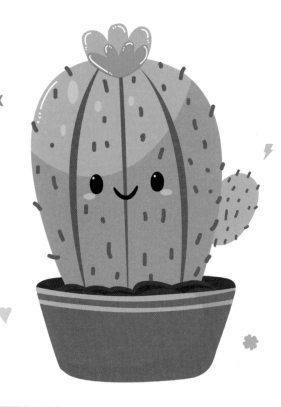

Cactus Charm

This charm isn't really prickly and can be made easily and quickly. Don't be a slowpoke. Let's get going!

Project time: 20 minutes

MATERIALS

Pot: 1 E-size piece Turquoise (Sculpey #505)

Soil in pot: 1 D-size piece Hazelnut (Sculpey #1657)

Cactus: 1 D-size piece Leaf Green (Sculpey #322) completely mixed with 1 F-size piece Granny Smith (Sculpey #1629)

Flower: 1 A-size piece Fuchsia Pearl (Sculpey #1112)

Face: 1 A-size piece Black (Sculpey #042)

½-inch-long (13 mm) eye pin

TOOLS

Medium ball stylus

Long eye pin

Diamond tip tool

Small ball stylus

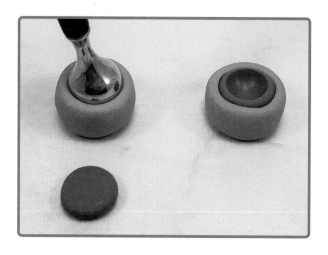

1. Condition your clay to make sure it's pliable and ready to work (see page 12). Roll each piece into a ball. Press the blue ball onto your work surface to create a flat, stable base, then flip it over and repeat on the other side, creating a thick, round shape. Flatten your brown ball into a disk with a slightly smaller circumference than the blue pot. Use your medium ball stylus to create a deep indent in the top of the blue pot. Fill the resulting indentation with the brown disk, and use the medium ball stylus to press it into place.

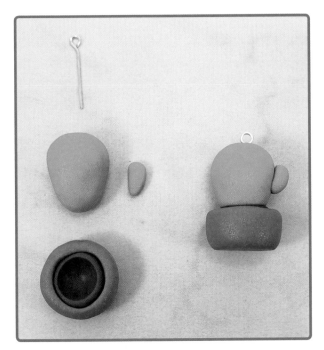

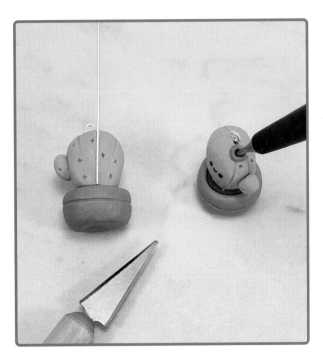

2. Pinch off a small piece from the green ball and form it into the shape of a rounded comma to use as an arm. With the larger green ball, create an oblong shape slightly tapered at the bottom to fit into the pot you just made. Press the green body of the cactus into the "soil" of the pot, and then attach the remaining green piece as a small arm on the side. Push the eye pin into the top of the main cactus piece.

3. Use the long eye pin to create the lines for the "segments" of the plant. Then, using shallow indents, poke the green body all over with the diamond tip tool to simulate the look of spines. Use the long eye pin to etch a small, even line along the rim of the pot to add a nice detail. Use your black clay to create two disks for the eyes and a short line for the mouth. Add the face details to the cactus where you think they look best. Place the fuchsia ball on the top of the cactus, to the side of the eye pin, and press your small ball stylus into the center of the clay, affixing it to the cactus and creating an indentation. This will create the cactus flower.

fantastic!

4. Bake the charm at 275°F (135°C) for 15 minutes. Allow to cool completely.

VARIATIONS
- Add different configurations for the arms.
- Change the body shape.
- Move or change the flower.
- Put a face on the pot instead of the cactus, or on both.
- Make smaller and flatter cacti as earrings.

S'mores Charm

This super-sweet miniature morsel is all it's cracked up to be. Why wait for camping? Let's cook one up right now!

Project time: 20 minutes

MATERIALS

Graham crackers: 2 E-size pieces Jewelry Gold (Sculpey #1132)

Chocolate bar: 1 D-size piece Hazelnut (Sculpey #1657)

Marshmallow: 1 E-size piece White (Sculpey #001)

Face: 1 A-size piece Black (Sculpey #042)

½-inch-long (13 mm) eye pin

TOOLS

Roller

Craft blade or knife

Long eye pin

Toothbrush

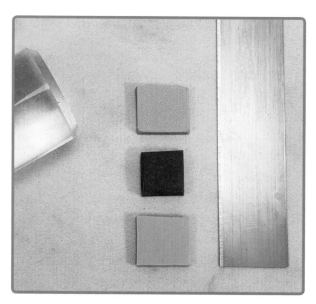

1. Condition your clay to make sure it's pliable and ready to work (see page 12). Roll each piece into a ball. Using your roller, roll out the crackers and the chocolate bar. Trim the edges with your craft blade to get them square and straight.

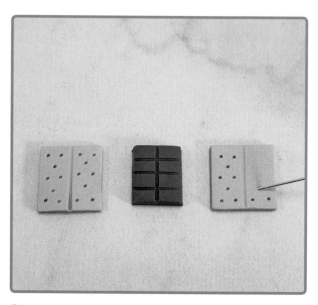

2. Using your long eye pin, create indentations for sections in the crackers and the chocolate bar, and then poke a pattern of small holes or indentations on the crackers.

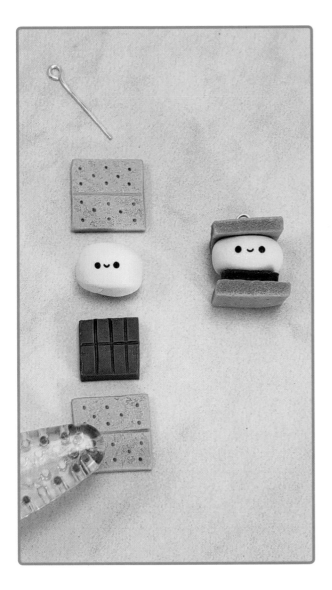

3. Shape the white clay into a short cylinder that is flat on the top and bottom. Use your black clay to create a small line for the mouth and two disks for the eyes, and put the face on the marshmallow where you think it looks best. Use the toothbrush to add texture to the crackers. To assemble your s'more, place one cracker on the bottom, and top it with the chocolate, marshmallow, and the other cracker. Once assembled, push down slightly to attach the various pieces to each other. Insert the [size TK] eye pin into the center of the top cracker.

excellent!

4. Bake the charm at 275°F (135°C) for 15 minutes. Allow to cool completely.

VARIATIONS

• Make smaller s'mores as earrings.

• Change the face.

• Add an open mouth.

• Bake slightly longer to get a toasted effect, but be careful to not let the piece discolor too much.

Ice Cream Charm

This is one of the coolest and sweetest charms. Wanna know how to make it? Here's the scoop! Also check out the Octopus Jewelry Holder on page 136.

Also check out the Octopus Jewelry Holder on page 136.

Project time: 15 minutes

MATERIALS

Cone: ½ section Jewelry Gold (Sculpey #1132)

Ice cream: 1 E-size piece Granny Smith (Sculpey #1629) completely mixed with 1 E-size piece Pearl (Sculpey #1101)

Chocolate chips: 1 B-size piece Hazelnut (Sculpey #1657)

Face: 1 A-size piece Black (Sculpey #042)

½-inch-long (13 mm) eye pin

TOOLS

Roller

Small circle cutter

Craft blade or knife

Long eye pin

Toothbrush

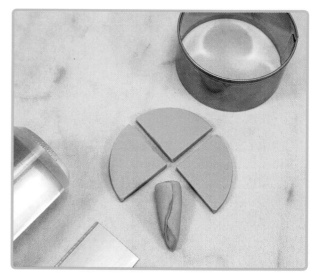

1. Condition your clay to make sure it's pliable and ready to work (see page 12). Roll each piece into a ball. Flatten the gold ball into a rough disk. Using your roller, roll out the disk until it's quite thin, and then use your circle cutter to cut out a perfect circle. With your craft blade, cut the circle into quarters. Take one of those quarters and roll it up into a cone, using the rounded edge as the top and the sharp point as the bottom.

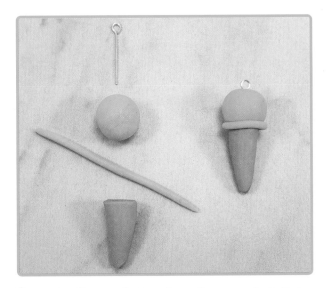

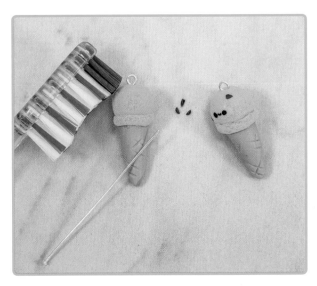

2. Pinch off a small piece from the green ball. Roll it out into a long strand. Roll the remaining piece into a ball. Place the ball in the cone, and then push the eye pin into the top of the ball. Next, wrap the green strand around the base of the ball where it touches the cone.

3. Use your long eye pin to create the waffle pattern on the cone. Use the toothbrush to create an ice cream–like texture on the green ball and strip. Divide the brown clay into four or five small dots for the chocolate chips. Place the chocolate chips where you think they look best. Use your black clay to create a small line for the mouth and two disks for the eyes, and place the face on the ice cream.

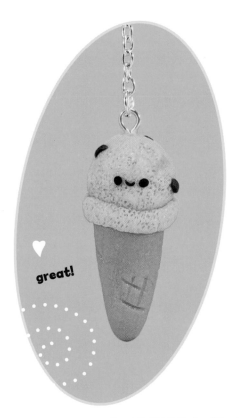

great!

VARIATIONS

- Make two smaller cones as earrings.
- Put the face on the cone instead of on the ice cream.
- Add an open mouth.
- Change the cone shape and/or texture.
- Change the ice cream color to whatever you'd like.
- Maybe add another scoop or two!

4. Bake the charm at 275°F (135°C) for 15 minutes. Allow to cool completely.

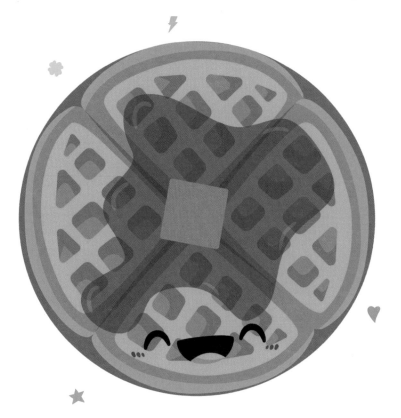

Waffle Charm

It's really hard to feel awful when you're always carrying around a sweet, little waffle. Let's make one!

Project time: 15 minutes

MATERIALS

Waffle: 1 F-size piece Jewelry Gold (Sculpey #1132)

Butter: 1 B-size piece Lemonade (Sculpey #1150)

Syrup: 1 C-size piece Hazelnut (Sculpey #1657)

Face: 1 A-size piece Black (Sculpey #042)

½-inch-long (13 mm) eye pin

Liquid Sculpey Translucent

TOOLS

Long eye pin

Small square-head (Robertson) screwdriver or driver bit

Small spatula

1. Condition your clay to make sure it's pliable and ready to work (see page 12). Roll each piece into a ball. Flatten the gold ball into a disk, slightly thicker in the middle than at the edges. Smooth and slightly round the disk. Insert the eye pin into the top of the disk at the edge. Use your long eye pin to make indentations to section the circle into quarters.

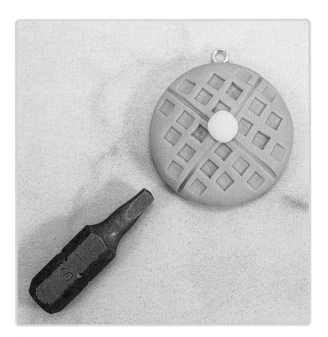

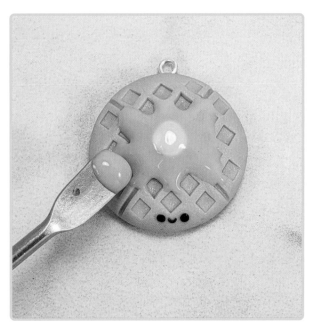

2. Use your square-head screwdriver or driver bit to create a regular pattern of indentations across the top of the waffle (or on both sides if desired). Flatten your yellow clay to create a small pat of butter. Carefully place the butter on top of the waffle.

3. Squirt a small amount of Liquid Sculpey onto your work surface. Pinch off a tiny piece of your brown clay and drop it into the liquid clay, using your small spatula to begin mixing the brown clay into the liquid clay. As the brown clay dissolves, add another small pinch to the mix, continuously stirring. Keep adding clay and mixing until the liquid clay takes on the color you prefer for the syrup. Use your small spatula to cover the butter and waffle with the syrup. Use your black clay to create a small line for the mouth and two disks for the eyes, and put the face where you think it looks best.

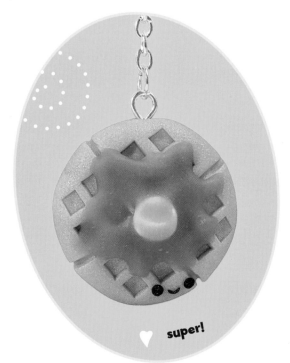

♥ **super!**

4. Bake the charm at 275°F (135°C) for 15 minutes. Allow to cool completely.

VARIATIONS

- Make two smaller waffles as earrings.
- Change the face shape and placement.
- Add small chocolate chip– or blueberry-shaped pieces.
- Change the syrup color to a fruit flavor.
- Make a whole stack!

Waffle Charm • **49**

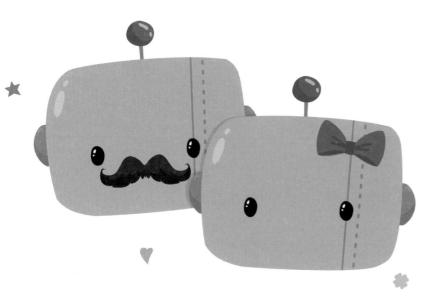

Robot Charms

This charming couple is automatically everyone's favorite. It's time to make these little love machines!

Project time: 20 minutes

MATERIALS

Robot heads: 2 F-size pieces Silver clay (Sculpey #1130)

Pink details: 1 B-size piece Fuchsia Pearl (Sculpey #1112) completely mixed with 1 B-size piece Pearl (Sculpey #1101)

Blue details: 1 B-size piece Turquoise (Sculpey #505)

Faces and mustache: 2 pinches Black (Sculpey #042), one slightly larger than the other

Two ½-inch-long (13 mm) eye pins

TOOLS

Long eye pin

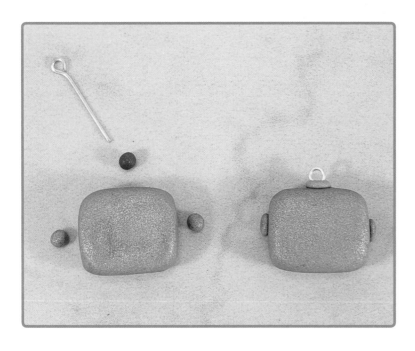

1. Condition your clay to make sure it's pliable and ready to work (see page 12). Roll each piece into a ball. Pinch off two small pieces from each of the two silver balls to use as the ears. Divide each ball into two smaller balls and then press until somewhat flattened. Shape the remaining silver balls into two rectangle shapes with rounded edges. Slightly flatten the fronts and backs. Attach the ears on either side of the heads. Take your small balls of blue and pink clay, and place them on the tops of the heads of the robots. Push the eye pins through the colored balls and into the robot heads, creating a cute detail.

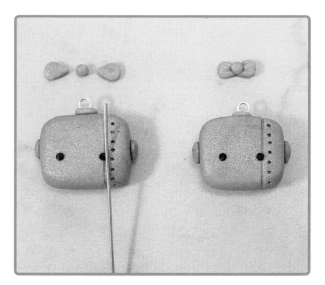

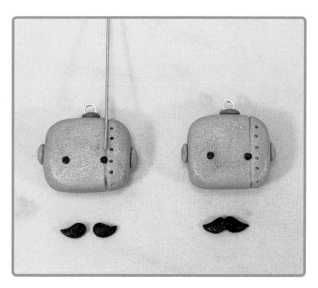

2. Use the long eye pin to press details (e.g., the vertical lines and the small dots that resemble rivets) onto the faces of the robots. Divide the smaller ball of black clay into four pieces, flatten them into dots for the eyes, and place them on the faces. For the pink robot, take the remaining pink clay and split it into three equal-size pieces to make the bow shape. Roll one piece into a ball for the center of the bow and form the remaining two pieces into teardrop shapes for the ends of the bow. Affix those shapes in the shape of a bow to the robot head. Use your long eye pin to make indentations on the bow to resemble how a tied bow looks.

3. To make the mustache for the blue robot, take the remaining piece of black clay and divide it into two comma-shaped pieces. Join these pieces together on the face of the robot to create the mustache shape. Use the eye pin to make even more details, if you desire, to both the fronts and backs of the charms.

VARIATIONS

- Make smaller robots as earrings.
- Change the face shape and placement.
- Add more details, such as a scarf, or change the ear color.
- Add a mouth.

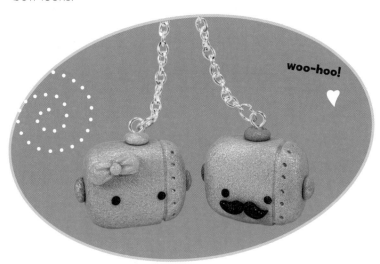

woo-hoo!

4. Bake the charms at 275°F (135°C) for 15 minutes. Allow to cool completely.

Book Charm

This is the perfect charm for those that never want to be without their favorite book. Let's peel back the cover on this project!

Project time: 20 minutes

MATERIALS

Cover: 1 F-size piece Gentle Plum (Sculpey #355) completely mixed with 1 E-size piece Pearl (Sculpey #1101)

Paper: 1 F-size piece White (Sculpey #001) completely mixed with 1 F-size piece Pearl (Sculpey #1101)

Pink heart: 1 C-size piece Ballerina Pink (Sculpey #1209)

½-inch-long (13 mm) eye pin

TOOLS

Roller

Craft blade or knife

Long eye pin

Wedge tip tool

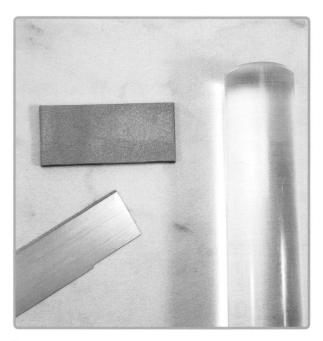

1. Condition your clay to make sure it's pliable and ready to work (see page 12). Roll each piece into a ball. Using the roller, flatten and evenly roll out the purple ball until it's about as thick as a credit card. Use your craft blade to trim it into a rectangle about 1 inch (2.5 cm) tall and 3 inches (7.5 cm) wide.

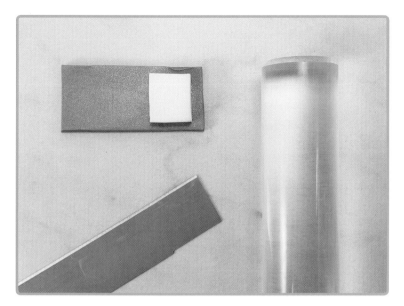

VARIATIONS

- Make smaller books as earrings.
- Add a cute face.
- Change the color of the cover.
- Use a long eye pin to emboss a book title on the front cover or spine.

2. Using the roller, flatten and roll out the white ball three to four times thicker than the clay for the cover. Use your craft blade to trim the edges into a small square approximately ¾ inch (2 cm) long on each side. Place the white clay on one end of the purple strip.

yippee!

3. Wrap the purple strip over the top of the white clay to enclose it on the top, bottom, and on one side. Push the eye pin through the top of the book's pages. Use your long eye pin to make embossed details on and around the spine of the book. With the small ball of pink clay, make a small, flat, and rounded cone shape. Use your wedge tool to cut a small wedge out of the pink shape to create a heart. Affix the heart to the book. Use the long eye pin to create parallel lines along the exposed edges of the white clay to simulate the look of pages.

4. Bake the charm at 275°F (135°C) for 15 minutes. Allow to cool completely.

Taco Charm

This spicy, little number might look complicated, but once it all stacks up, you'll see how fresh and easy it really is. So stop taco-ing about it and start doing it!

Project time: 20 minutes

MATERIALS

Shell: 1 F-size piece Yellow (Sculpey #072) completely mixed with 1 E-size piece Jewelry Gold (Sculpey #1132)

Meat: 1 E-size piece Hazelnut (Sculpey #1657)

Lettuce: 1 D-size piece Granny Smith (Sculpey #1629)

Tomato: 1 D-size piece Deep Red Pearl (Sculpey #1140)

Cheese: 1 B-size piece Lemonade (Sculpey #1150)

Face: 1 A-size piece Black (Sculpey #042)

½-inch-long (13 mm) eye pin

TOOLS

Roller

Medium circle cutter

Needle tool

Toothbrush

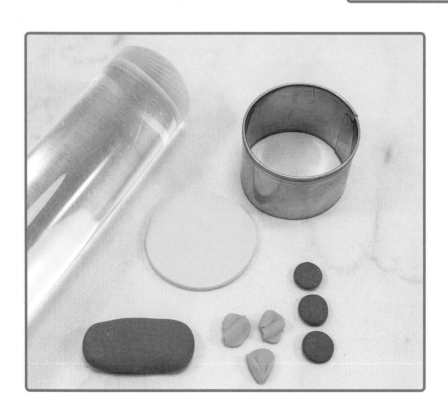

1. Condition your clay to make sure it's pliable and ready to work (see page 12). Roll each piece into a ball. Flatten and roll out the yellow ball for the shell until it is about as thick as a credit card. Use the circle cutter to create a round disk. Shape the brown ball into a rounded rectangle, and flatten it to about three times the thickness of the shell. Shape the green ball into three small lettuce leaves. Divide the red ball into three round balls of equal size, and then flatten them into small disks to be tomatoes.

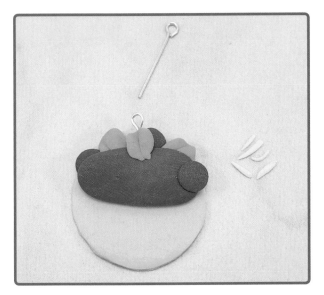

2. Take the other yellow ball for the cheese and roll it out to flatten it. Then cut it into small strips to simulate shredded cheese. Assemble the taco by artfully arranging the meat, tomatoes, and lettuce inside the taco shell, and then fold the other half of the taco shell over. Push the eye pin into the meat slab in the middle, making sure it'll stick up high enough to leave the loop exposed. Don't forget to add the shredded cheese!

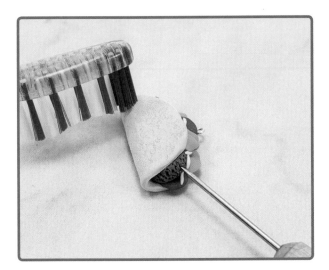

3. Use the needle tool to create a meat-like texture and to make sure everything is tucked in, secure, and arranged the way you like it. Use the toothbrush to create texture on the outside of the taco shell. Use your black clay to create a small line for the mouth and two disks for the eyes, and place the face where you think it looks best.

VARIATIONS

- Make smaller tacos as earrings.
- Change the face details.
- Add different ingredients to your taco, such as sour cream or hot peppers.
- Make it bigger for a brooch.

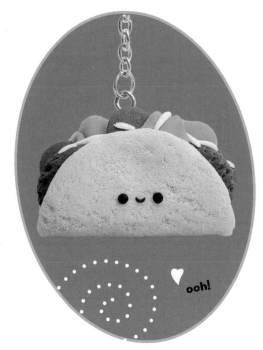

ooh!

4. Bake the charm at 275°F (135°C) for 15 minutes. Allow to cool completely.

French Toast Charm

Ooooooh la la! This French toast may look fancy but it is easy to make. Let's whip up a batch!

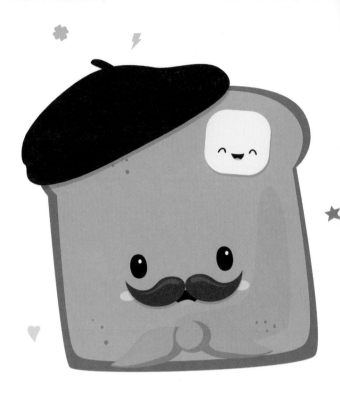

Project time: 20 minutes

MATERIALS

Toast: 1 E-size piece Jewelry Gold (Sculpey #1132)

Beret, mustache, and eyes: 1 C-size piece Black (Sculpey #042)

Tie: 1 B-size piece Deep Red Pearl (Sculpey #1140)

½-inch-long (13 mm) eye pin

TOOLS

Toothbrush

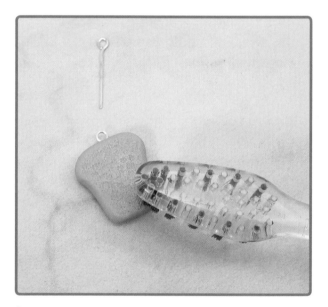

1. Condition your clay to make sure it's pliable and ready to work (see page 12). Roll each piece into a ball. Partially flatten and then shape your gold ball into a slice of bread. Insert the eye pin centered into the top of the slice. Use the toothbrush to add texture to both sides of the toast.

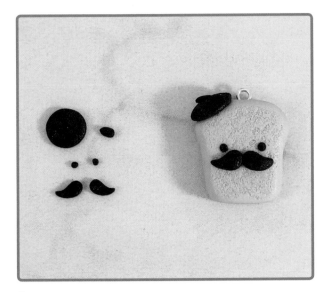

VARIATIONS
- Make smaller toasts as earrings.
- Change the face details.
- Change the hat color.
- Add a pat of butter.
- Change the bow-tie color.
- Make it bigger for a brooch or pin.

2. Divide the black clay into five pieces: two tiny disks for the eyes, two small comma-shaped pieces for the mustache, a larger disk for the beret, and a small piece for the stem of the beret. Affix the beret disk to the top of the French toast, pinch it to give it a little shape, and add the stem. Apply the eyes and mustache onto the front of the toast.

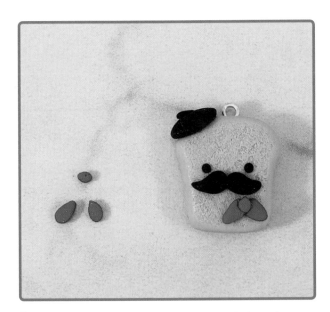

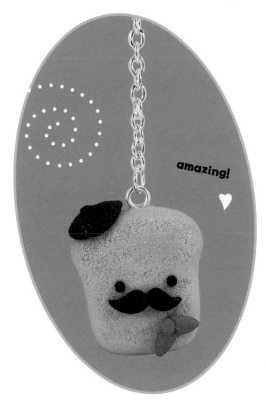

amazing!

3. Divide the red clay into three equal-size pieces. Create two small comma-shaped pieces and one small ball. Arrange the large ends of the comma-shaped pieces so that they're touching and then add the ball where they meet, to create a loose bow tie. Apply the tie to the French toast just below the mustache and jauntily placed off to one side.

4. Bake the charm at 275°F (135°C) for 15 minutes. Allow to cool completely.

Narwhal Charm

This perky, little fellow in teal will always make a pointed fashion statement.
Let's dive in deep!

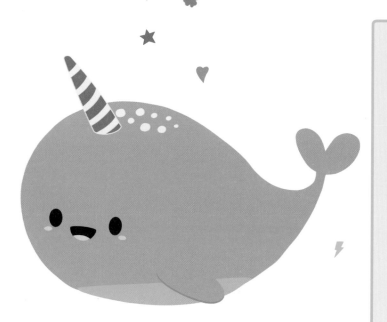

Project time: 20 minutes

MATERIALS

Body: ½ section Teal Pearl (Sculpey #538)

Horn and dots: 1 D-size piece Pearl (Sculpey #1101)

Face: 1 A-size piece Black (Sculpey #042)

½-inch-long (13 mm) eye pin

½-inch-long (13 mm) eye pin shaft, for support

Liquid Sculpey Pearl

TOOLS

Chisel tip shaper

Medium ball stylus

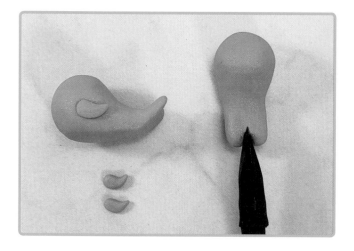

1. Condition your clay to make sure it's pliable and ready to work (see page 12). Roll each piece into a ball. Pinch off two small pieces from the teal ball for the fins. Shape the remaining teal ball into a large comma, with a more ball-like structure on one end for the head and a flat, tapered piece on the other end for the tail. Use your chisel tip shaper to cut a small notch into the tapered end for the tail. Round and flatten the ends of the tail, smoothing out the whole shape. Take the two small pinches of teal clay and fashion small teardrop shapes for fins. Slightly flatten the fins and affix them to the sides of the body.

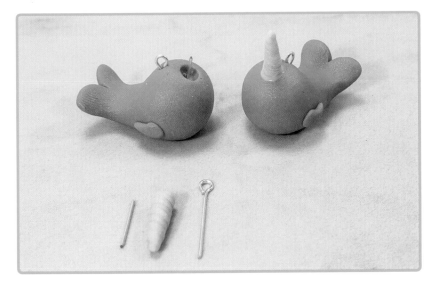

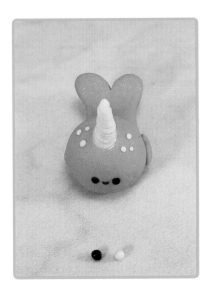

2. Slide the eye pin into the mid-back of the figure, so it will hang properly balanced. Pinch off a few small pieces from the white ball and form them into small balls for dots. Use the remaining white ball to roll a tapered horn, about ½ inch (13 mm) long, and twist it into shape. Use your medium ball stylus to create a deep indent in the top of the narwhal's head. Insert the eye pin shaft into the indentation as support. Then, push the horn down onto that post and into the indent, along with a drop of Liquid Sculpey to make sure the horn is firmly affixed.

3. Add the white dots to the back and sides of the head. Use your black clay to create a small line for the mouth and two disks for the eyes. Put them on the front of the narwhal where you think they look best.

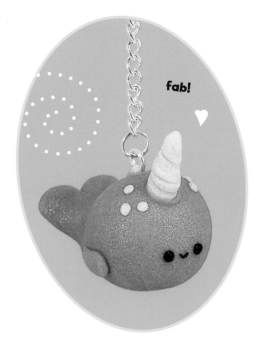

fab!

VARIATIONS

- Change the face details.
- Add an open mouth.
- Change the horn color or make it multicolored.
- Change the color of the body.

4. Bake the charm at 275°F (135°C) for 15 minutes. Allow to cool completely.

Sea Turtle Figurine

This turtle-y awesome project is going to go swimmingly. Give this to someone and they'll follow you to shell and back.

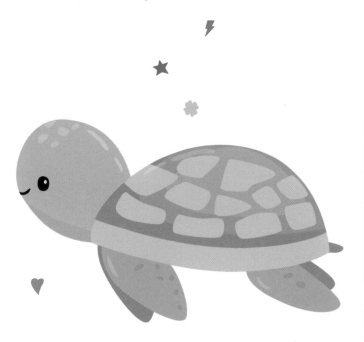

Project time: 20 minutes

MATERIALS

Head and body: ½ section Teal Pearl (Sculpey #538) completely mixed with ½ section Pearl (Sculpey #1101)

Spots, flippers, and strip around shell: 2 E-size pieces Teal Pearl (Sculpey #538) combined together

Face: 1 A-size piece Black (Sculpey #042)

½-inch-long (13 mm) eye pin shaft, for support

Liquid Sculpey Translucent

TOOLS

Small ball stylus

1. Condition your clay to make sure it's pliable and ready to work (see page 12). Roll each piece into a ball. Divide the lighter teal ball into three main pieces: three-fifths of the ball for the body and one-fifth each for the head and the piece to cover the bottom of the turtle. Form the body into a slightly oval shape, roll the head into a ball, and flatten the bottom cover into a disk. Divide the darker teal ball into four B-size pieces for the flippers; one C-size piece, rolled into a long strip to encircle the entire turtle shell; an A-size piece for the tail; and a couple of A-size pieces, divided into a number of tiny pieces, for the spots on the head and shell.

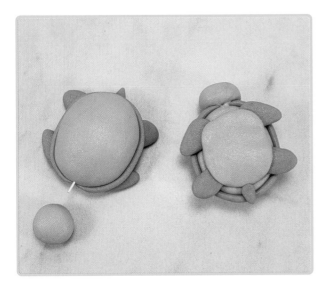

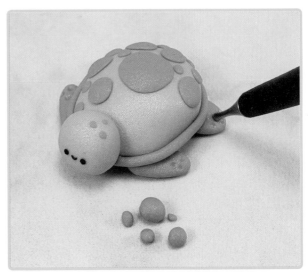

2. Begin assembling the turtle. Use the eye pin shaft and a drop of Liquid Sculpey to secure the head to the body. Attach the flippers and tail to the bottom of the turtle, and then cover with the flat bottom piece. Take the long strip and wind it around the bottom perimeter of the shell.

3. Add the darker teal spots to the head and the back and sides of the shell. Use the small ball stylus to add texture and details to the spots and flippers. Use your black clay to create a small line for the mouth and two disks for the eyes. Put them on the front of the turtle's head where you think they look best.

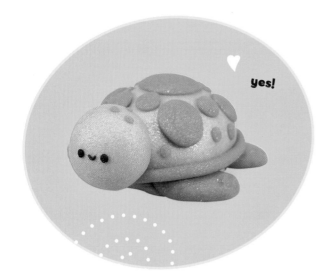

yes!

VARIATIONS
- Change the face details.
- Add an open mouth.
- Change the color of the body or the spots or both.
- Add a little hat.
- Put a snail on its back.

4. Bake the figurine at 275°F (135°C) for 20 minutes. Allow to cool completely.

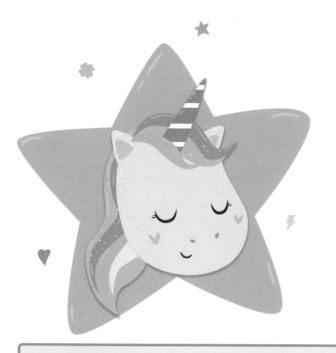

Unicorn Brooch

Wearing this cute and colorful brooch will make you feel extra special. Let's make some magic!

Project time: 25 minutes

MATERIALS

Star base: ¾ section Pearl (Sculpey #1101) completely mixed with 1 E-size piece Turquoise (Sculpey #505)

Head and chest: 2 E-size pieces Pearl (Sculpey #1101) completely mixed with 2 E-size pieces White (Sculpey #001)

Horn and pink mane: 1 E-size piece Pearl (Sculpey #1101) completely mixed with 1 B-size piece Fuchsia Pearl (Sculpey #1112)

Green mane: 1 E-size piece Pearl (Sculpey #1101) completely mixed with 1 B-size piece Granny Smith (Sculpey #1629)

Purple mane: 1 D-size piece Pearl (Sculpey #1101) completely mixed with 1 C-size piece Gentle Plum (Sculpey #355)

Face: 1 A-size piece Black (Sculpey #042)

½-inch-long (13 mm) eye pin shaft, for support

Liquid Sculpey Translucent

Brooch clasp backing

Craft glue (E6000 brand or similar)

TOOLS

Roller

Small star-shaped cutter

Medium ball stylus

Small ball stylus

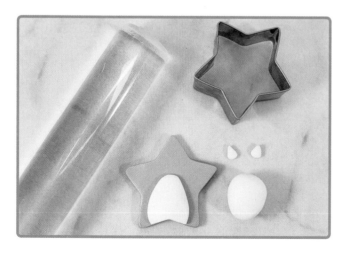

1. Condition your clay to make sure it's pliable and ready to work (see page 12). Roll each piece into a ball. Divide your white ball into three pieces: one E-size piece for the chest, two A-size pieces for the ears, and the remaining piece for the head. Roll out the blue ball about ⅛ inch (3 mm) thick. Use the small star-shaped cutter to cut out a star shape. Use the white clay for the chest to create a rough triangular shape that follows the contours of the bottom of the star shape. Apply the chest to the star, making sure it is firmly affixed. Shape the small pinch of white clay into ears and shape the remaining piece of white clay into a horse head.

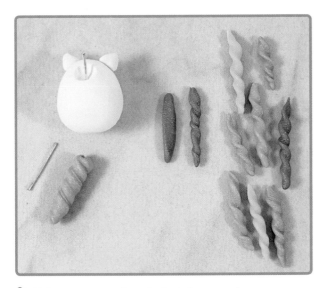

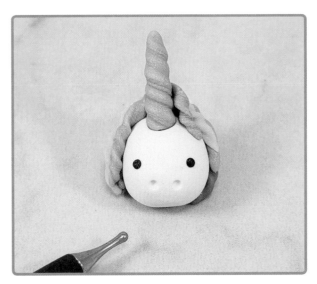

2. Using your medium ball stylus, create an indentation in the top center of the horse head. Attach the ears to the head on either side of the hole and just behind it. Place the eye pin shaft into the center of the indentation to act as a support for the horn. Roll out the colored clay into ten thin strands (three each of blue and purple and two each of pink and green), about ½ inch (13 mm) long. For the horn, use the remaining pink clay to roll a thick, tapered horn, about ½ inch (13 mm) long, and twist it into shape.

3. Press the horn onto the eye pin shaft and into the indent, along with a drop of Liquid Sculpey to make sure the horn is firmly affixed. To create the rainbow mane, arrange the twisted hair strands around the horn and ears. Use your black clay to create two small disks for the eyes and place them on the front of the head. Use your small ball stylus to create two nostrils below the eyes.

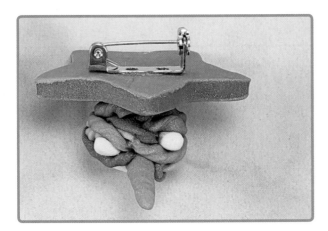

4. Affix the head to the chest piece and star by pressing gently but firmly, being careful not to deform the head. Bake the brooch at 275°F (135°C) for 20 minutes. Allow to cool completely. Attach the brooch clasp on the back of the star with some clear craft glue, pressing firmly to make sure it's secure. Allow the glue to fully cure before wearing the brooch.

VARIATIONS

- Change the face details.
- Add a mouth.
- Change the color of the head and chest, horn, mane, or star.
- Make the eyes more serene.

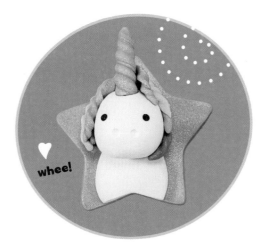

♥
whee!

Pineapple Heart Planter

This sweet little yellow fellow has a lot of heart and he's super easy to make. Let's get growing!

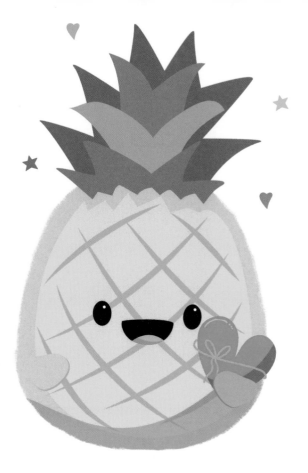

Project time: 20 minutes

MATERIALS

Pineapple: 1 F-size piece Yellow (Sculpey #072)

Heart: 1 B-size piece Deep Red Pearl (Sculpey #1140)

Face: 1 A-size piece Black (Sculpey #042)

1 small air plant (*Tillandsia*)

TOOLS

Large ball stylus

Needle tool

Chisel tip shaper

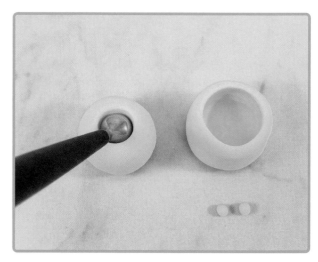

1. Condition your clay to make sure it's pliable and ready to work (see page 12). Roll each piece into a ball. Pinch off two small pieces from the yellow ball for little arms in step 2. Shape the remaining yellow ball into a wide, solid cylinder shape. Use your large ball stylus to create an indentation in the cylinder and then continue to use the stylus to create a solid-bottom pot with even sides, 1 to 1½ inches (2.5 to 4 cm) deep.

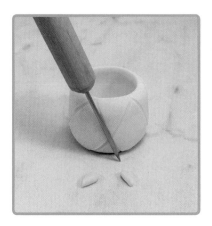

2. Use your needle tool to create a crisscross or crosshatch pattern on the outside of the pot. To make the arms, shape the small yellow clay pieces into oblongs that are slightly tapered at one end, flattening them slightly.

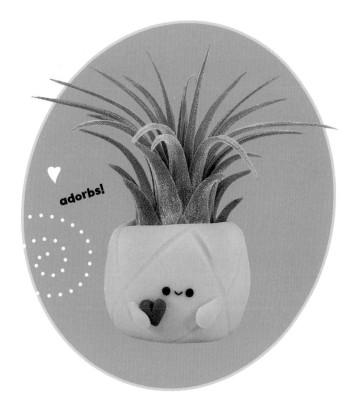

adorbs!

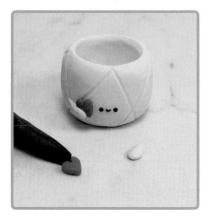

3. Shape the red clay into a teardrop and flatten slightly. Use your chisel tip shaper to cut a small notch out of the bigger end, creating a heart shape. Use your black clay to create a small line for the mouth and two disks for the eyes. Apply the face to the pineapple. Attach the two arms closer to the front of the pineapple and below the face, wrapping the heart in one of them. Press them firmly but gently to the body of the pineapple, being careful to not deform the clay.

4. Bake the pineapple at 275°F (135°C) for about 15 minutes. Allow to cool completely. Add an air plant, which doesn't require soil. The plant needs to be spritzed with cool, clean water every couple of days and should also be soaked for 10 minutes or so in cool, clean water, once every couple of weeks. Just make sure that the plant drains completely after soaking it, as standing water can eventually rot the root bulb. Keep the plant indoors, preferably in a moist environment (kitchens and bathrooms are great). Indirect or intermittent sunlight is better than direct, harsh sunlight, as that can burn the plant.

VARIATIONS
- Change the face details.
- Glue a magnet to the back of the pineapple to create a paperclip holder.
- Make a whole pineapple family.
- Replace the heart with something else.

Hanging Jellyfish Planter

Brighten any space with this cute, little planter. Put it up and watch all your friends get totally jelly. Let's do this sting!

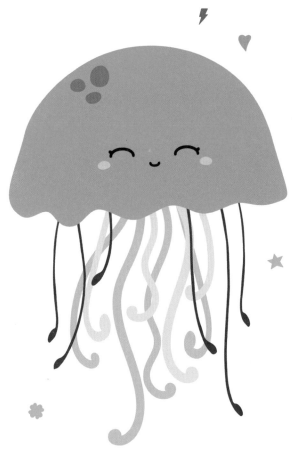

Project time: 20 minutes

MATERIALS

Body: 1 section Sweet Potato (Sculpey #033) completely mixed with 1 F-size piece Pearl (Sculpey #1101)

Fringe ruffle and spots: 1 F-size piece Pearl (Sculpey #1101) completely mixed with 1 E-size piece Sweet Potato (Sculpey #033)

Face: 1 A-size piece Black (Sculpey #042)

18 inches (46 cm) white string, for hanging

Craft glue (E6000 brand or similar)

1 small air plant (*Tillandsia*)

TOOLS

Large ball stylus

Needle tool

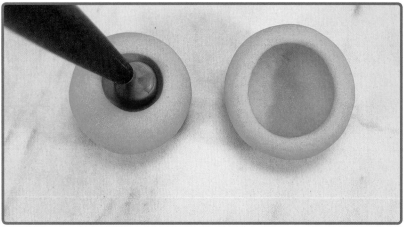

1. Condition your clay to make sure it's pliable and ready to work (see page 12). Roll each piece into a ball. Gently press the bottom of the ball onto your work surface to flatten slightly. Use your large ball stylus to create an indentation in the bottom of the ball, and then continue to use the stylus to create a large hole inside the ball, about 1 inch (2.5 cm) deep. Slightly taper the opening to create a small rim.

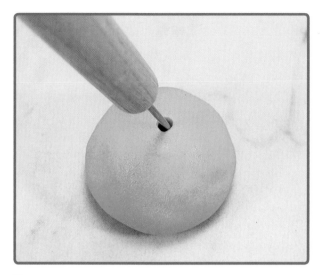

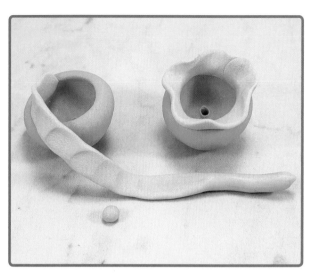

2. Use your needle tool to poke a hole through the top of the jellyfish. Make sure the hole is centered, clean, and large enough for the string to pass through when doubled up.

3. Flip the jellyfish over to expose the hole underneath. Pinch off a small piece of the lighter orange clay, and then use the palm of your hand to roll out the remainder of the clay into a strand about 1 inch (2.5 cm) long. Use your fingers to pinch the strand flat. Attach it to the rim around the hole of the jellyfish, creating a ruffle skirt around the bottom. Make sure to maintain the smooth round shape of the jellyfish.

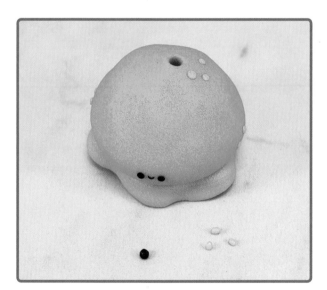

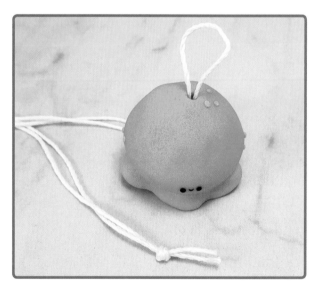

4. Use your black clay to create a small line for the mouth and two disks for the eyes, and affix them where you think they look best. Divide the remaining pinch of light orange clay into a few small dots. Place them on the head of the jellyfish, as little freckles or spots, again wherever you think they look best.

5. Bake the jellyfish at 275°F (135°C) for about 15 minutes. Allow to cool completely. Double up your piece of string and tie a knot with the two ends to create a big loop. Feed the string through the hole (with the knot inside the jellyfish).

(continued)

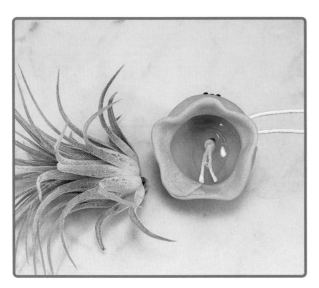

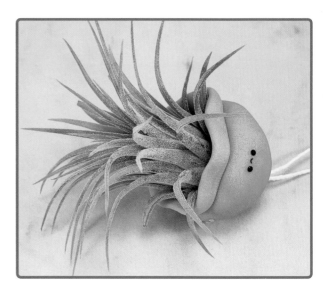

6. Make sure your air plant will fit inside the bottom of the jellyfish. Carefully peel off a few leaves if you need to make it fit. Smaller is OK. Trim the ends of the string hanging inside if necessary.

7. Put a small drop of glue inside the jellyfish and carefully add the air plant, holding the plant in place for a minute to make sure the glue sets around it. Allow the glue to dry and cure (about 24 hours) before hanging the planter.

8. The plant needs to be spritzed with cool, clean water every couple of days. The plant should also be soaked for 10 minutes or so in cool, clean water, once every couple of weeks. The polymer clay is virtually waterproof, so you can soak the entire planter when you need to soak the plant. Just make sure that the water drains completely after soaking the planter, as standing water can eventually rot the root bulb. Hang the plant indoors, preferably in a moist environment (kitchens and bathrooms are great). Indirect or intermittent sunlight is better than direct, harsh sunlight, as that can burn the plant.

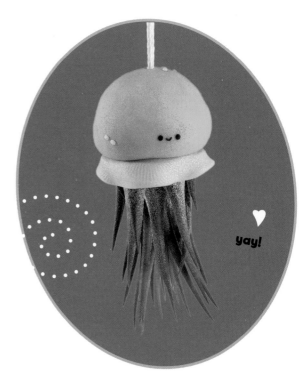

yay!

VARIATIONS

- Change or omit the face details.
- Change the color of the body, the ruffle fringe, or both.
- Choose an air plant in a different shape and color to give a different effect.
- Add texture or a pattern to the jelly's head.
- Use Sculpey's glow-in-the-dark clay to create a fun effect.

Narwhal Photo Holder

OK, picture this: an adorable little narwhal on your desk, holding your favorite photo. Let's make one!

Project time: 25 minutes

MATERIALS

Body: 1 F-size piece Purple (Sculpey #513) completely mixed with 1 section plus 1 F-size piece Pearl (Sculpey #1101)

Horn and spots: 1 F-size piece Pearl (Sculpey #1101) and 1 F-size piece Purple (Sculpey #513), unmixed

Heart: 1 B-size piece Teal Pearl (Sculpey #538)

Face: 1 pinch Black (Sculpey #042)

2-inch-long (5 cm) eye pin shaft, for support

Liquid Sculpey Translucent

5-inch-long (12.5 cm) 16-gauge round wire, for photo holder

TOOLS

Chisel tip shaper

Needle tool

Medium ball stylus

Needle-nose pliers

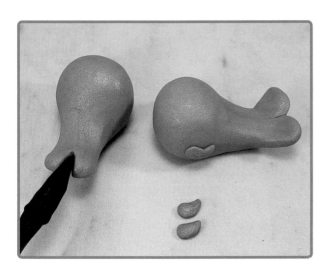

1. Condition your clay to make sure it's pliable and ready to work (see page 12). Roll each piece into a ball. Pinch off two small pieces from the light purple ball for the fins. Shape the remaining light purple ball into a large comma, with a more ball-like structure on one end for the head and a flat, tapered end for the tail. Use your chisel tip shaper to cut a small notch into the tail. Round and flatten the ends of the tail, smoothing out the whole shape. Gently press it down on your work surface to create a flat, stable bottom. Form the two small pinches of light purple clay into small teardrop shapes for fins. Slightly flatten those and affix them to the sides of the body.

(continued)

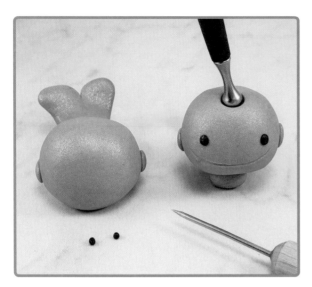

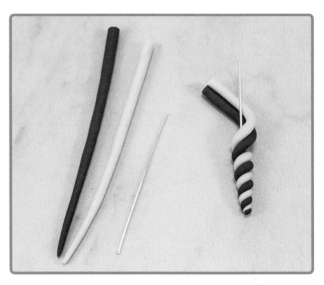

2. Use your black clay to form two small disks for the eyes. Put them on the front of the narwhal wherever you think they look best. Use your needle tool to trace out a line below the eyes as a smiling mouth. Using your medium ball stylus, make a small, shallow indentation on the top of the head, between the eyes, for the horn to sit in.

3. Pinch off a piece from the white ball and set aside. Roll out the remaining white ball into a long, thin strand, tapering at one end. Repeat with the dark purple ball. Starting with the tapered ends, press the two strands together slightly and then begin wrapping the strands around the eye pin shaft, ending with the thicker ends near the bottom and making sure ¼ inch (6 mm) of the eye pin is exposed.

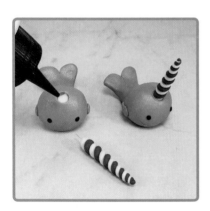

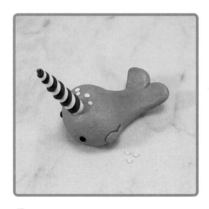

4. Add a drop of Liquid Sculpey to the indentation on the head of the narwhal, and then add the horn, sliding the exposed pin into the clay. Make sure the base of the horn is fully seated in the hole with the Liquid Sculpey. Gently remove any excess Liquid Sculpey from the base of the horn.

5. Take the remaining pinch of white clay and divide it into several small balls. Flatten the balls into disks and apply them around the horn as spots.

VARIATIONS

- Change the face details by adding an open mouth or altering the eye shape.

- Change the color of the body, horn, or heart.

- Add a different small detail instead of the heart, such as a shell or a starfish.

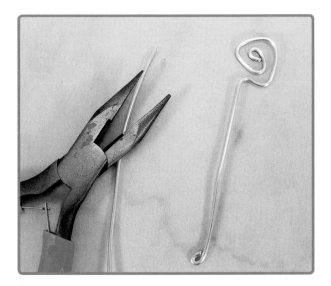

6. Use your needle-nose pliers to bend one end of your 16-gauge round wire into a couple of loops, to be used to hold a single card or photo. Trim the wire to your desired length, making sure to leave enough to sink ½ inch (13 mm) deep into the narwhal. Bend the other end over onto itself doubling it up to create a small tight loop that will serve as an anchor.

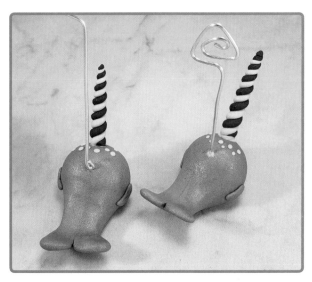

7. Slide the small end of the wire into the back of the narwhal, centered just behind the horn, making sure it's almost fully vertical when the narwhal is sitting on the work surface. Once you've inserted the wire into the narwhal, twist it slightly to ensure the clay has a good grip on the wire. Make sure that the top of the wire is oriented to your desired direction for displaying a photo. Use a drop of Liquid Sculpey to seal the hole around the wire.

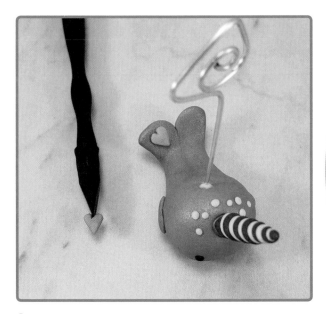

8. Shape your ball of teal clay into a teardrop. Flatten slightly and then use your chisel tip shaper to carve out a small notch in the larger end to form a heart shape. Affix the heart to the tail of the narwhal.

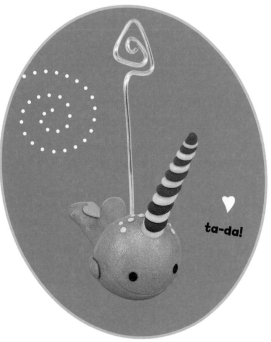

ta-da!

9. Bake the narwhal at 250°F (120°C) for 35 minutes. Allow to cool completely.

Project time: 15 minutes

MATERIALS
Body: 1 section Hazelnut (Sculpey #1657)

Head: 1 E-size piece Jewelry Gold
(Sculpey #1132)

Bow: 1 B-size piece Princess Pearl
(Sculpey #530)

Face: 1 A-size piece Black (Sculpey #042)

1 small air plant (*Tillandsia*)

TOOLS
Large ball stylus

Needle tool

Hedgehog Planter

It might look a little prickly, but this planter project will go smoothly,
I promise. Let's hit all the high points!

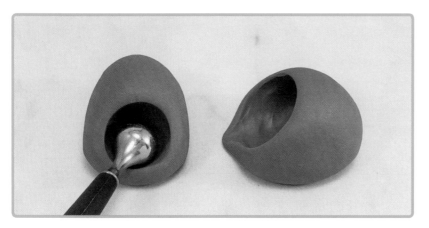

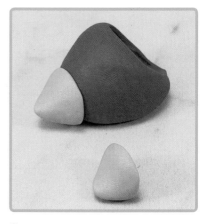

1. Condition your clay to make sure it's pliable and ready to work
(see page 12). Roll each piece into a ball. Form the brown ball into a
roundish, oblong shape, slightly tapered at one end. Gently press it
down on your work surface to create a flat, stable bottom. Use your
large ball stylus to press a deep indentation into the larger, non-
tapered side of the shape. Keep working until the hole is about 1 inch
(2.5 cm) deep. Pinch the bottom of the hole opening to create a
stubby little "tail."

2. Shape your gold ball into a
cone. Affix it to the tapered end
of the brown clay piece. Press
firmly but gently to make sure
it's secure without misshaping
the clay.

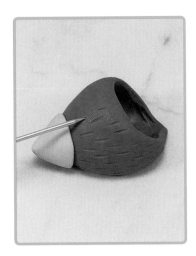

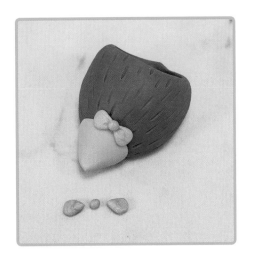

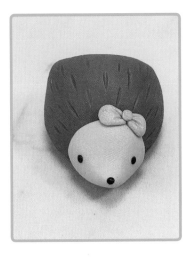

3. Use your needle tool to make a bunch of small lines in the body, simulating the look of quills lying flat.

4. Divide your pink ball into three pieces, two larger and one smaller. Create a ball with the smallest piece and two teardrop shapes with the larger pieces. Use your needle tool to add details to the teardrop shapes to simulate the folding of a ribbon. Put the three pieces together where the head meets the body, to form a bow, affixing it with the needle tool to make sure it's secure.

5. Take the black clay and form three small disks. Put two of the disks on either side of the face as eyes and the third on the tip of the gold cone to complete the nose.

6. Bake the hedgehog at 275°F (135°C) for 20 minutes. Allow to cool completely. Add an air plant, which doesn't require soil. The plant needs to be spritzed with cool, clean water every couple of days. The plant should also be soaked for 10 minutes or so in cool, clean water, once every couple of weeks. Just make sure that the plant drains completely after soaking it. Keep the plant indoors, preferably in a moist environment (kitchens and bathrooms are great). Indirect or intermittent sunlight is better than direct, harsh sunlight, as that can burn the plant.

VARIATIONS

• Change the face details by adding an open mouth or altering the eye shape.

• Change the color of the bow tie.

• Glue a magnet to the inside of the hole and use as a paper clip holder.

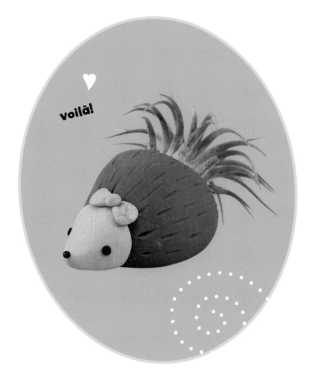

voilà!

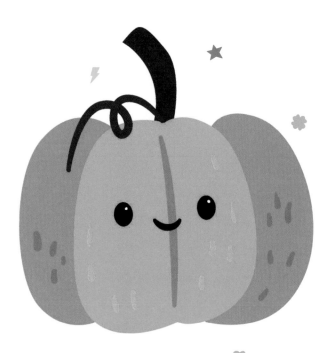

Pumpkin Planter

Orange you glad I included a pumpkin project? It's a gourd one and as easy as pie!

Project time: 20 minutes

MATERIALS

Pumpkin: 1 section Sweet Potato (Sculpey #033)

Stem: 1 B-size piece Hazelnut (Sculpey #1657)

Leaves: 1 D-size piece Leaf Green (Sculpey #322)

Face: 1 A-size piece Black (Sculpey #042)

1 small air plant (*Tillandsia*)

TOOLS

Large ball stylus

Chisel tip shaper

1. Condition your clay to make sure it's pliable and ready to work (see page 12). Roll each piece into a ball. Lightly press the orange ball against your work surface to create a flat, smooth base. Use your large ball stylus to create a hole in the center of the top of the ball. Keep working the tool around, maintaining the round shape, until the hole is about 1 inch (2.5 cm) deep. Smooth the top over slightly to create a small ridge around the opening.

2. Use your chisel tip shaper to create indentations around the top hole, taking some of them all the way down the sides of the pot to simulate the section lines of a pumpkin. Be sure to create some indentations around the base, too, to finish the illusion.

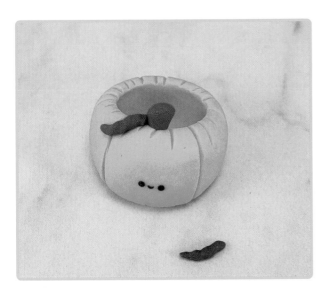

wow!

3. Using your brown ball, roll out a slightly tapered, short rod to be the stem of the pumpkin. It doesn't need to be perfect or symmetrical. Take the small ball of green clay and form two twisted vines to attach to the stem you just created. Affix the stem and vines to the top of the pumpkin, just inside the front of the hole. Use your black clay to create a short line for the mouth and two small disks for the eyes. Affix the face to the pumpkin below the stem, wherever you think it looks best.

VARIATIONS

- Change the face details by adding an open mouth or altering the eye shape.
- Glue a magnet to the inside and back of the hole and convert to a paper clip holder.
- Make an apple instead of a pumpkin by changing the main color to green or red and shaping it slightly different.

4. Bake the pumpkin at 275°F (135°C) for 20 minutes. Allow to cool completely. Add an air plant, which that doesn't require soil. The plant needs to be spritzed with cool, clean water every couple of days and should also be soaked for 10 minutes or so in cool, clean water once every couple of weeks. Just make sure that the plant drains completely after soaking it. Keep the plant indoors, preferably in a moist environment (kitchens and bathrooms are great). Indirect or intermittent sunlight is better than direct, harsh sunlight, as that can burn the plant.

Hanging Sloth Pendant

Just take it slow, and this project will be as easy to make as it is cute.
And don't worry, I won't leave you hanging.

Project time: 25 minutes

MATERIALS

Branch: 2 E-size pieces Tan (Sculpey #301) mixed together

Body and eye patches: 1 section Hazelnut (Sculpey #1657)

Head and face: 1 D-size piece Jewelry Gold (Sculpey #1132)

Leaves and flower: 1 C-size piece Granny Smith (Sculpey #1629), 1 C-size piece Leaf Green (Sculpey #322), and 1 B-size piece Gentle Plum (Sculpey #355), unmixed

Face: 1 A-size piece Black (Sculpey #042)

2-inch-long (5 cm) eye pin shaft, for support

Two ½-inch-long (13 mm) eye pins

Jewelry chain (optional)

TOOLS

Needle tool

2-inch-long (5 cm) eye pin

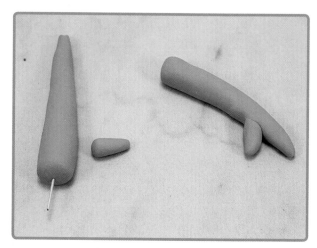

1. Condition your clay to make sure it's pliable and ready to work (see page 12). Roll each piece into a ball. Pinch off a small piece of your tan ball and shape it into a short cone. Roll the remaining tan ball into a tapered rod, bent slightly up near the tapered end. Insert the eye pin shaft into the larger end to act as a support. Attach the short cone to the main piece to create a branch.

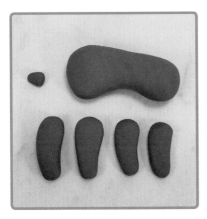

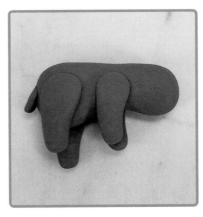

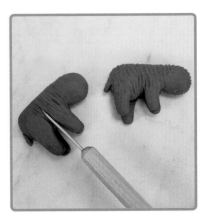

2. Divide your brown ball into seven pieces: two D-size pieces for the front legs, two E-size pieces for the back legs, an A-size piece for the tail, a small pinch for the face details in step 5, and the remaining large piece for the body. Shape the body piece into a peanut shape and the arms and legs into pieces that are wider on top and taper toward the bottom.

3. Attach the front and back legs to the body. Press firmly but gently to affix them without distorting the shape of the clay. Add the tail and smooth everything out with your finger to create a whole piece.

4. Use your needle tool to etch short lines all over the body and arms and legs to simulate the look of fur.

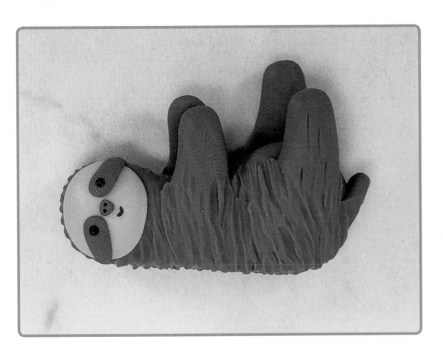

5. Flatten the small ball of gold clay into a disk, slightly smaller than the size of the "head" piece of the body. Affix the face to the side of the head. Take the pinch of brown you set aside earlier to create two comma-shaped pieces. Flatten those out and apply to the face as eye patches. Use a tiny piece as a small dot in the middle for the nose, and place it between the eyes. Use your needle tool to create the nostril indentations. Use your pinch of black to create a short line for the mouth and two small disks for the eyes. Affix the face details.

(continued)

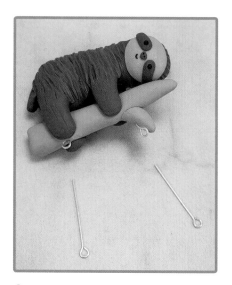

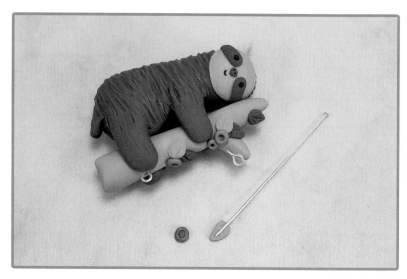

6. Attach the sloth to the stick by wrapping the legs around either side, so it's hugging it. Press firmly but gently to make sure it's secure. Slide your eye pin clasp holders through the branch all the way into the sloth body, placing them so the pendant will hang balanced.

7. Divide both balls of green clay into three small pinches each. Flatten them and work them into small leaf shapes. Use your long eye pin to etch details, such as veins, on the leaves. To make the flowers, divide your plum ball into five equal-size pieces and roll them into smooth balls. Use your long eye pin to create the flower details and to gently but firmly attach the flowers to the branch where you think they look best and to slightly flatten them. Attach the leaves to the branch under and around the flowers.

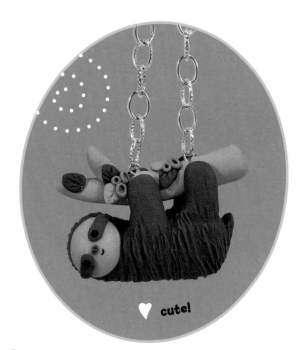

♥ **cute!**

VARIATIONS

• Change the face details by adding an open mouth or altering the eye shape.

• Add different details on the branch, including textures, other critters, etc.

• Add a brooch back to wear it as a pin.

8. Bake the sloth at 250°F (120°C) for 30 minutes. Allow to cool completely before hanging. Add a chain with clasps to the eye pins in the branch.

Crystal Card Holder

This rock-solid project is as elegant as it is useful. Here are the crystal-clear instructions you need!

Project time: 30 minutes

MATERIALS

Base: 1½ sections White (Sculpey #001) completely mixed with 1½ sections Pearl (Sculpey #1101)

Crystals: 2 sections Pearl (Sculpey #1101), divided into thirds; ½ section Purple (Sculpey #513); ½ section Teal Pearl (Sculpey #538); and ½ section Fuchsia Pink (Sculpey #1112)

Several 2-inch-long (5 cm) headpins, cut into eight 1- to 2-inch-long (2.5 to 5 cm) pieces, for support

Liquid Sculpey Pearl

TOOLS

Roller

Craft blade or knife

Small ball stylus

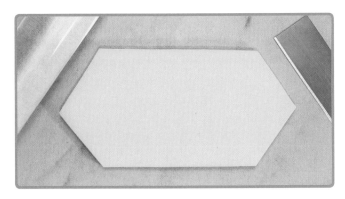

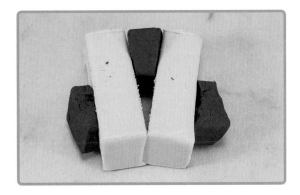

1. Condition your clay to make sure it's pliable and ready to work (see page 12). Roll each piece into a ball. Roll out your pearl ball for the base into a long, oblong shape, about ½ inch (13 mm) thick. Use your craft blade to trim the base into the shape you want and square up the edges. Set aside.

2. Take one-third of the pearl clay for the crystals and cut it into two long rectangles. Cut your purple clay into three equal-sized pieces, placing it around and between the two pearl rectangles. Repeat this step for the teal and pink colors. *(continued)*

3. Partially mix each of the colors by folding them over onto themselves slowly to form a marbled look. Be careful not to overmix the clay or the colors will blend together completely.

4. Roll out each marbled colored piece into rods about ½ inch (13 mm) thick. Use your craft blade to divide the rods into various lengths.

5. Use your craft blade to trim and square off the edges, making a crystalline shape with angles, peaks, and flat surfaces.

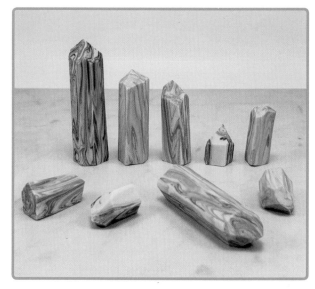

6. Using your craft blade, cut a few small pieces from the larger "crystals" to use along the base later. Make sure they have hard angles and smooth surfaces.

7. Arrange your various marbled pieces until you get a placement that looks good to you. Take a photo of it so you remember how you want it to go together on the base, or just move the base next to your arrangement before final assembly and then move each piece over one at a time.

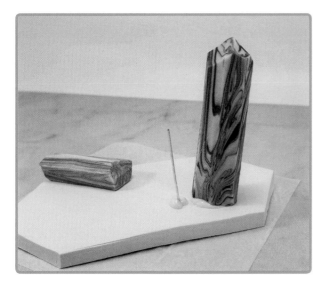

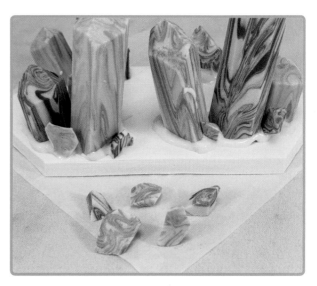

8. Use your pieces of eye pin to create anchor points for your large crystal pieces. Do this by placing one of the pins into the base, at the angle you want, and then putting a small drop of Liquid Sculpey around the base of the pin, before sliding the longer crystal pieces onto the pins and gently affixing them to the base. Repeat for all the of the larger crystal pieces.

9. Affix the remaining small pieces with a small amount of Liquid Sculpey so they look like small crystal outcroppings around the larger pieces. Use your small ball stylus tool to help secure the pieces by pressing them down to the base. Arrange these smaller pieces the way you think they look best.

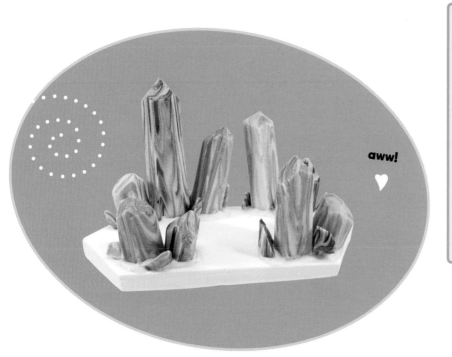

aww!

♥

VARIATIONS

• Add face details to some crystals to make it more kawaii.

• Use different colors for the base or the crystals.

• Arrange the crystals so the holder fits a stack of sticky notes or another desk item.

10. Bake the piece at 250°F (120°C) for 25 minutes. Allow to cool completely before using.

Whale Ice Cream Ring Holder

If you like it, you should put a ring on it! This silly little whale will hold your ring securely without fail. Let's break the surface and dive deep into this cute project.

Project time: 30 minutes

MATERIALS

Whale: 1 section plus 1 F-size piece Light Blue Pearl (Sculpey #1103) mixed together

Cone: 1 F-size piece Jewelry Gold (Sculpey #1132)

Ice cream: 1 C-size piece White (Sculpey #001)

Tongue: 1 B-size piece Princess Pearl (Sculpey #530)

Face: 1 A-size piece Black (Sculpey #042)

Sprinkles: Tiny pinches of whatever colors you prefer

1-inch-long (2.5 cm) eye pin shaft, for support

Liquid Sculpey Pearl

TOOLS

Chisel tip shaper

Long eye pin

Wedge tip tool

Needle tool

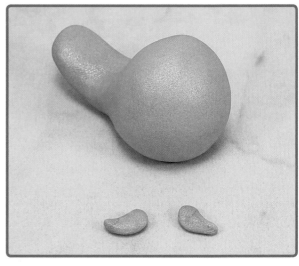

1. Condition your clay to make sure it's pliable and ready to work (see page 12). Roll each piece into a ball. Pinch off two B-size pieces from your blue ball. Shape those pieces into flattened commas to attach as fins in step 2. Work the remaining blue ball into a teardrop shape, tilting the small end out while bending it up and flattening it out slightly for the tail. Smooth and round out the large end to form the head. Gently press the whole whale body on your work surface to create a stable, flat bottom.

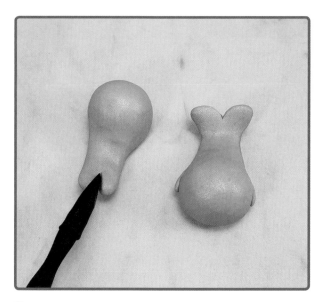

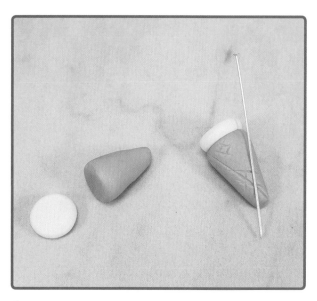

2. Use your chisel tip shaper to cut a small notch into the tapered end to create the tail shape. Smooth and round out the tips of the tail. Take the two small blue fins you set aside earlier and press them against each side of the head of the whale, near the bottom of the figure.

3. Shape the gold ball into a small cone. Flatten your white ball into a disk, about ¼ inch (6 mm) thick. Affix the white disk to the blunt end of the cone. Use your long eye pin to create a waffle pattern on the cone.

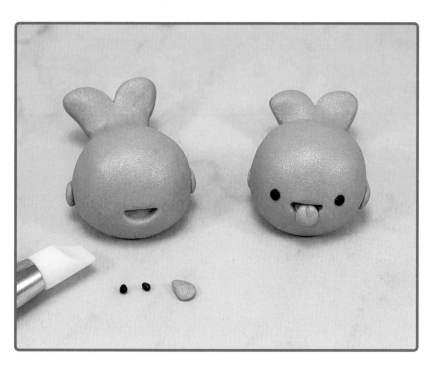

4. Use your wedge tip tool to press a small indentation into the front of the whale head to create a shallow hole for the mouth. Take the black clay and make two small disks for the eyes. Place the eyes on either side of the mouth where you think they look best. Shape your pink ball into a flat teardrop shape for the tongue. Use your long eye pin to press a small indentation in the center of it. Place the small end of the pink piece into the mouth and carefully affix it with your needle tool.

(continued)

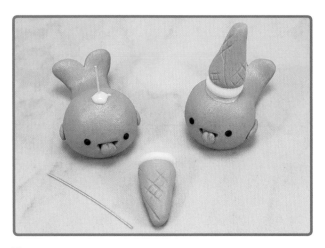

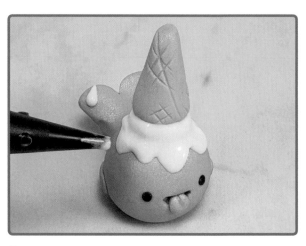

5. Place the eye pin shaft into the top of the whale's head, centered and tilted very slightly to the back. Put a drop of Liquid Sculpey around the base of the pin. Slide the cone onto the metal post, making sure the white disk is firmly affixed to the top of the whale and is in good contact with the liquid clay.

6. Squeeze a few drops and drips of Liquid Sculpey from the white base of the cone onto the whale's head, simulating a dripping scoop of ice cream. Put a small drop on the tail, too, as a fun detail.

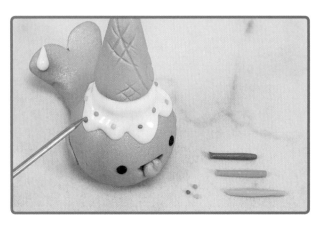

7. Roll out your colored balls into short, thin strands. Use your needle tool to cut off small sprinkle-shaped pieces, and place them carefully into the still-wet liquid clay of the ice cream.

VARIATIONS

- Change the face details.
- Change the colors of the ice cream, cone, or whale.
- Play with the texture or shape of the cone.
- Put a drop of ice cream on teh whale's tongue.

love!

8. Bake the ring holder at 250°F (120°C) for 30 minutes. Allow to cool completely before using.

Llama Rubber Band Holder

This sleepy little llama will carry your desk supplies with no drama. Just follow all the steps, and it won't go south on you.

Project time: 35 minutes

MATERIALS

Llama body and head: 1 full brick Pearl (Sculpey #1101) completely mixed with 2 F-size pieces Tan (Sculpey #301)

Inside ears: 1 C-size piece Tan (Sculpey #301)

Blanket and tassels: 1 F-size piece Sweet Potato (Sculpey #001); 1 F-size piece Fuchsia Pearl (Sculpey #1112); 1 F-size piece Turquoise (Sculpey #505); 1 F-size piece Pearl (Sculpey #1101) completely mixed with 1 C-size piece Purple (Sculpey #513); and 1 D-size piece Elephant Gray (Sculpey #1645)

Face: 1 A-size piece Black (Sculpey #042)

1½-inch-long (4 cm) 16-gauge round wire, for support

Two ½-inch-long (13 mm) eye pin shafts, for support

TOOLS

Roller

Craft blade or knife

Diamond tip tool

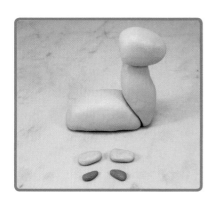

1. Condition your clay to make sure it's pliable and ready to work (see page 12). Roll each piece into a ball. Pinch off three C-size pieces from the large ball of light tan clay and set aside to use as the ears and tail in step 3. Divide the remaining light tan ball into three pieces: one the size of 1¼ sections for the neck, one piece that is the size of ¾ section for the head, and the remaining clay for the body. Shape them accordingly (see the photo). Slightly bend your 16-gauge round wire so that you can press it through the neck piece, exposing both ends of the wire at either end of the neck. Use these metal posts as anchors, first to affix the neck to the body and then to affix the head to the neck.

(continued)

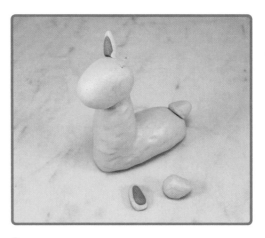

2. Smooth out the joins to form a whole figure. Use your fingertips to create small indentations all over the figure to make it look a little "fluffy." Press the figure gently but firmly onto your work surface to create a flat, stable base.

3. Take the three pinches of light tan clay you set aside, and shape them into a small ball for the tail and two elongated shapes for the ears. For the inner ear, divide your tan clay into two equal-size pieces and shape them slightly smaller than the ears. Press the inner-ear shapes onto the main ear shapes. Gently press the two eye pin shafts into the head of the llama where you want the ears to go, and then affix the ears to the head by sliding them over the eye pins and pressing them firmly into the head.

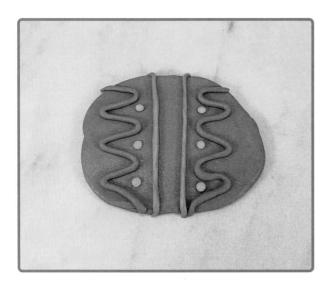

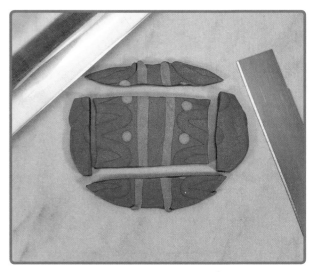

4. Pinch off two A-size pieces each of your orange, fuchsia, turquoise, and purple balls and set aside to use as tassels in step 6. Take the remaining turquoise ball and use your roller tool to make a fairly flat disk, approximately ⅛ inch (3 mm) thick and the size of a business card. Roll the remaining orange, fuchsia, and purple balls into long strands and then use those strands (either in pieces or whole) to create and lay out a unique design on the top of the turquoise disk.

5. Gently and carefully use your roller to flatten the design on top of the turquoise disk. Once it's flattened out and the design is clear, use your craft blade to trim it into a clean rectangle.

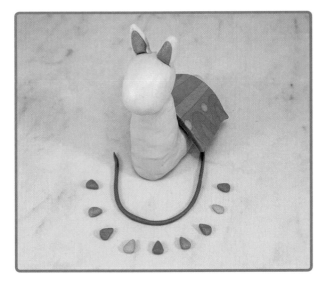

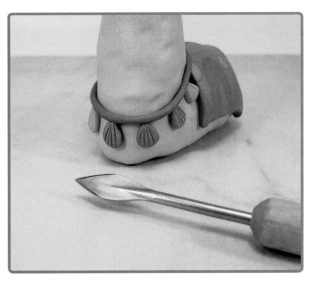

6. Use your palm to roll out the gray ball into a long, thin strand, about 4 inches (10 cm) long. Take the small pinches of color you set aside earlier and make them into small teardrop shapes. Lay them out around the gray strand to get your colors and design the way you want it.

7. Wrap the gray strand around your llama's neck and connect the two ends. Attach the small colored pieces to the bottom of the gray strand, affixing everything to the body of the llama. Use your diamond tip tool to poke in lines on the small colored pieces to simulate tassels.

8. Use your black clay to create two small lines for the eyes and one small disk for the nose. Apply them to the head of the llama where you think they look best.

VARIATIONS
- Change the face details.
- Add a mouth.
- Put a figure on the llama's back.
- Change the colors of the tassels or the blanket.
- Change the texture of the llama's body by using your needle tool to make lines to simulate hair.

9. Bake the rubber band holder at 250°F (120°C) for 40 minutes. Allow to cool completely before using.

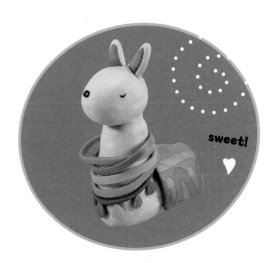

sweet!

Bunny and Carrot Figurine

You are going to adore this hare-raising project! I'll be rooting for you while you make some bunny to love. Let's begin.

Project time: 35 minutes

MATERIALS

Carrot: 1½ sections Sweet Potato (Sculpey #033)

Carrot top: 1 E-size piece Leaf Green (Sculpey #301) completely mixed with ½ section Granny Smith (Sculpey #1629)

Bunny body, limbs, and outside ears: 1 F-size piece Tan (Sculpey #301) completely mixed with 1 E-size piece Hazelnut (Sculpey #1657)

Bunny tail: 1 B-size piece Tan (Sculpey #301)

Foot pads, inside ears, and nose: 1 B-size piece Princess Pearl (Sculpey #530)

Face: 1 A-size piece Black (Sculpey #042)

½-inch-long (13 mm) eye pin shaft, for support

Two ¼-inch-long (6 mm) eye pin shafts, for support

Liquid Sculpey Translucent

TOOLS

Chisel tip shaper

Large ball stylus

Needle tool

1. Condition your clay to make sure it's pliable and ready to work (see page 12). Roll each piece into a ball. Use your palm to roll out the orange ball into a thick strand, about ½ inch (13 mm) wide at the base, and tapered to a blunt tip at the other end, creating a rough carrot shape. Use your chisel tip shaper to create a carrot-like texture and indentations. Use your large ball stylus to make a shallow indentation in the blunt end of the carrot to create an opening for the carrot greens. Make a smaill ridge around the opening.

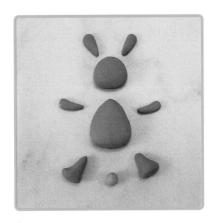
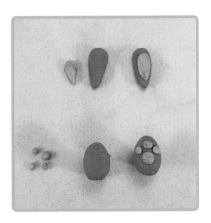

2. Divide your green ball into six small equal-size pieces. Roll them into short strands with a slight taper on one end. Arrange them inside the hole you made in the carrot, affixing them to the sides and to each other to create the look of carrot greens. Slightly press the carrot onto your work surface to make a stable, flat bottom. Bake the carrot now, without the bunny, at 250°F (120°C) for 15 minutes. Allow to cool completely. (Tip! Make your bunny while the carrot is baking and cooling.)

3. Divide your brown ball into eight pieces: one D-size piece for the body, one C-size piece for the head, two B-size pieces for the back legs, and four A-size pieces for the front legs and outer ears. Shape accordingly (see the photo). Roll your tan ball into a smooth ball for the tail.

4. Divide your pink ball into seven small balls (each about half the size of an A-size piece), two A-size balls, and two oblong A-size pieces that are slightly smaller than the outer ears you made earlier. Set one of the seven smaller ball aside to use for the nose in step 7. Flatten the remaining six balls into disks. Flatten the two A-size balls and apply these disks to the bottoms of the back legs as foot pads and the six smaller disks as the toe pads. Apply the oblong pink pieces to the insides of the outer ear pieces.

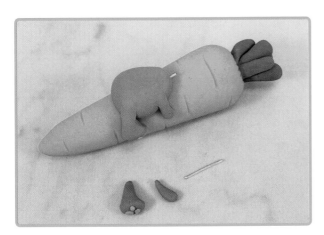
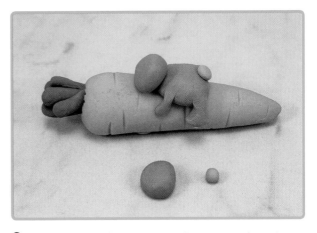

5. Gently and carefully place your bunny's body onto your carrot, pressing slightly to make sure it's secure. Affix the legs to the body and smooth out the joins with your fingers to create a whole shape. Push your longer eye pin shaft into the neck of the bunny body, leaving some of the pin exposed.

6. Press the head piece onto the exposed section of eye pin shaft. Make sure it's sitting properly on the carrot. Affix the tail to the bottom of the bunny.

(continued)

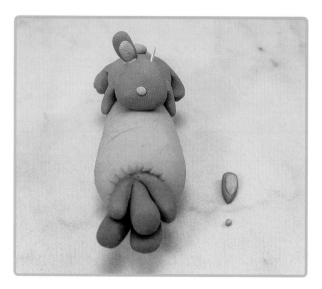

7. Put the two smaller eye pin shafts into the head of the bunny near the back, leaving some of the pin exposed to create posts to anchor the ears. Once in place, add a small drop of Liquid Sculpey to each post, and then slide the ears over the posts and affix to the head. Take your remaining small ball of pink clay, flatten it, and affix it to the front of the bunny's head for the nose.

8. Take your black clay and form two small lines to create the eyes. Place them on the face where you think they look best.

VARIATIONS

- Change the face details.
- Add a mouth.
- Add a second bunny.
- Change the texture of the bunny's body by using your needle tool to make lines to simulate fur.
- Omit the green clay, make the top indentation of the carrot bigger and deeper, and place an air plant in the top hole of the carrot instead.

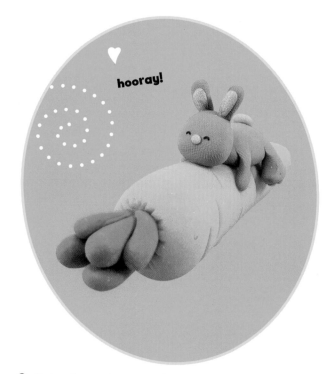

hooray!

9. Bake the entire piece, bunny and carrot together, at 250°F (120°C) for 15 minutes. Allow to cool completely before using.

Volcano Matchstick Holder

This hot, little project will light up your life and it's way easier to make than you think. Let's have some monster fun!

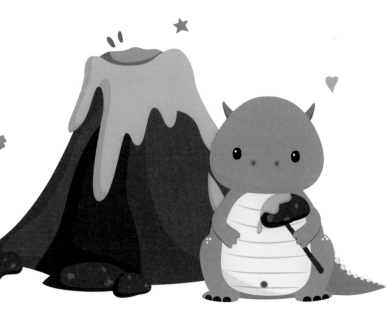

Project time: 45 minutes

MATERIALS

Ocean base: 2 sections Blue (Sculpey #063); ½ section Pearl (Sculpey #1101); and 1 section Pearl (Sculpey #1101) completely mixed with 1 F-size piece Blue (Sculpey #063) to create a light blue color

Island base: 1½ sections Hazelnut (Sculpey #1657)

Volcano: 2½ sections Hazelnut (Sculpey #1657)

Lava: ¾ section Deep Red Pearl (Sculpey #1140) slightly mixed and gently folded with 1 F-size piece Sweet Potato (Sculpey #033) to create a marbled effect (don't overmix)

Rocks: ½ section Black (Sculpey #042)

Monster: ¾ section Elephant Gray (Sculpey #1645) and 1 D-size piece Cactus Green (two mixed colors; see page 42 for recipe)

Face: 1 pinch Black (Sculpey #042)

½-inch-long (13 mm) eye pin shaft, for support

Matchsticks

TOOLS

Roller

Large ball stylus

Small ball stylus

Needle tool

Long eye pin

Chisel tip shaper

1. Condition your clay to make sure it's pliable and ready to work (see page 12). Roll each piece into a ball. Flatten the three balls for the ocean base. Gently fold those flat pieces together until the mixed clay has a marbled appearance, and then roll the clay into a ball. Using your roller, roll out the marbled blue clay ball into a disk, about ¼ inch (6 mm) thick, that resembles the surface of the ocean. Roll out your brown ball into a flat disk for the island base, about two-thirds the size of the ocean base. Place the island onto the ocean and make sure it's secure.

(continued)

2. Form the brown ball for the volcano into a rough cone. Press the bottom down on your work surface to create a stable, flat base. Use your large ball stylus to create an indentation at the top of the cone, eventually working the tool and the clay until you've molded out a large hole that goes almost to the bottom. Smooth the lip at the rim.

3. Place the volcano on the island base and smooth the two together to make sure they are firmly affixed and you've created a gentle slope down to the island base. Use your large ball stylus to press the volcano down in the center to ensure it's secured to the base.

4. Pinch off a small piece of the lava ball and set aside. Divide up and roll the remaining lava ball into several long strands. Slightly flatten those strands to create strips of varying lengths. Lay the strips around the rim of the volcano and down the sides to simulate flowing lava. Use your small ball stylus to create a dimpled, bubbling texture in the lava strips.

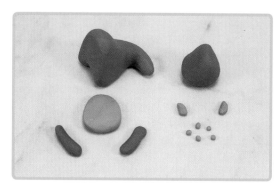

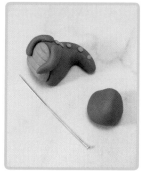

5. Divide your black ball into several small, rough balls of varying sizes to simulate rocks. Take the remaining small piece of lava and divide it into several small pinches. Lay those pinches on the rocks to simulate the look of fresh lava cooling on black rocks. Use your small ball stylus and needle tool to create a rough, rock-like texture on them.

6. Divide your gray ball into four pieces: one about the size of ½ section for the monster's body and tail, one about the size of ¼ section for the head, and two A-size, comma-shaped pieces for the arms. Shape the body/tail into a teardrop shape, with the tapered end as the tail and the thicker end flattened up for the body. Form the head into a rough ball with a sloping front for the snout. Divide your green ball into one D-size piece slightly flattened into a rounded triangle for the chest, two small, comma-shaped pieces for the horns, and five or six tiny pinches of clay for the spots along the monster's back and tail.

7. Affix the green chest plate to the front of the monster's body. Use your long eye pin to create a horizontal-lined pattern in the chest plate. Affix the arms to the sides, wrapping them around the chest slightly. Place the green dots along the back and the tail of the body.

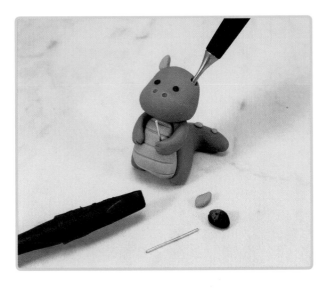

8. Affix the head to the body, smoothing the joins to create a secure hold. Use your small ball stylus to create nostrils in the front of the head and holes for the horns at the top of the head. Place the horns in the holes and smooth out the edges. Use your black clay to create two small disks for the eyes and place them on the face, pressing down gently, making sure they are securely affixed. Take your eye pin shaft and insert it into the top and front of one of the arms, at a slight angle, so there is about ½ inch (13 mm) exposed at the top. Take one of the lava rocks you made earlier and slide it onto the exposed pin to create a lollipop effect. Use your chisel tip shaper to create small indentations on the hands, to simulate the appearance of short fingers.

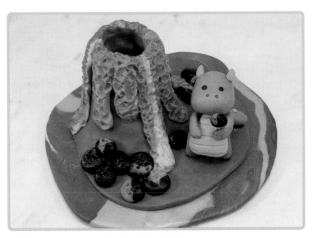

9. Assemble the pieces, placing the rocks and lava monster where you think they look best. Slightly press the pieces together to make sure they are securely affixed.

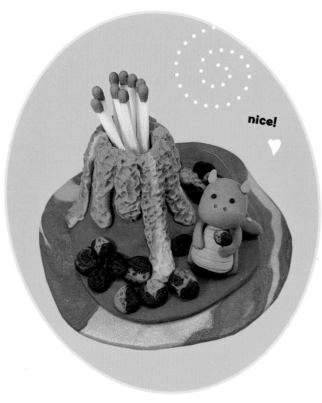

nice! ♥

VARIATIONS

• Use the top hole as a planter.
• Change the color of the monster.
• Add cute details like a tongue for the monster (see the Whale Ring Holder on page 82 for details), a starfish on the island, or a shark fin in the water.
• Glue a small piece of sandpaper or match striker on the back of the volcano to strike the matches on.

10. Bake the holder at 250°F (120°C) for 40 minutes. Allow to cool completely before using. Finish by adding the matchsticks.

Otter Couple Figurines

This perky pair are the perfect project to make with your significant otter. You're gonna love how it all fits together

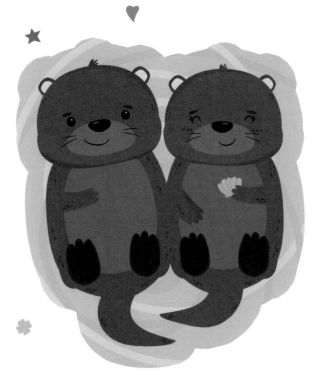

Project time: 40 minutes

MATERIALS

Main bodies: 2 sections Hazelnut (Sculpey #1657) completely mixed with ½ section Tan (Sculpey #301)

Tummies and feet: 1 F-size piece Tan (Sculpey #301)

Heart: ¼ section Pearl (Sculpey #1101) completely mixed with 1 D-size piece Fuchsia Pearl (Sculpey #1112)

Faces: 2 A-size pieces Black (Sculpey #042)

Two 1-inch-long (2.5 cm) eye pin shafts, for support

Two ⅛-inch (3 mm) round craft magnets

Craft glue (E6000 brand or similar)

TOOLS

Curved carving tool

Craft blade or knife

Chisel tip shaper

Small ball stylus

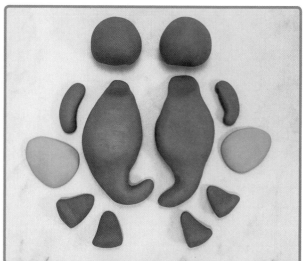

1. Condition your clay to make sure it's pliable and ready to work (see page 12). Roll each piece into a ball. Divide your brown ball into fourteen pieces: two ¾ sections for the bodies, two ¼ sections for the heads, six D-size pieces for the arms and legs, and four pieces each about half the size of an A-size piece for the ears. Shape accordingly (see the photo). Pinch off two A-size pieces from the tan ball to use in step 7 as the foot pads. Divide the remaining tan ball into two equal-size pieces to be the otters' tummies. Shape the foot pads into slightly flattened disks and the tummy pieces into flattened, rounded triangles.

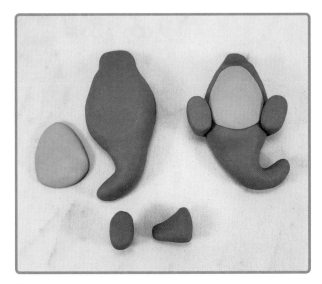

2. Assemble the bodies of the otters by adding the tummy pieces, making sure they are securely attached to the main bodies. Also add the back legs, with the bottoms facing up.

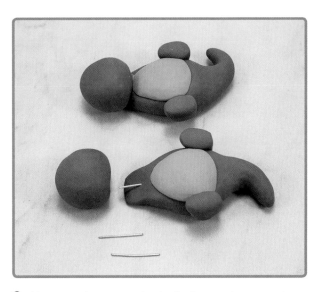

3. Use your two eye pin shafts to create an anchor for the heads, by pushing a pin down through the neck and into the body of each otter, making sure to leave a small section sticking out. Slide the head pieces onto the metal posts and smooth out the joins with your fingers, being careful to not distort the head shape.

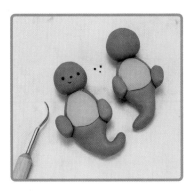

4. Use your black clay to create four small disks for the eyes and two even smaller disks for the noses, and apply them to the otters' heads. Use your curved carving tool to make an indentation below the noses for smiling mouths.

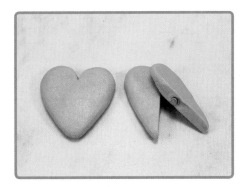

5. Work your pink ball into a smooth heart shape, slightly flattening it on your work surface. Use your craft blade to make a clean cut in the middle of the heart to create two halves. Gently, so as not to distort the heart shape, press a small magnet into each side of the heart, making sure that they are oriented to attract each other. Ensure that the magnets are flush with the cut edges of the heart, so when they join together, there is only a small seam. Carefully remove the magnets before baking.

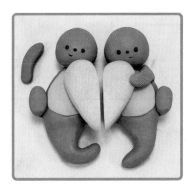

6. Place the heart halves on each otter, so they line up. Add the arms, slightly wrapping them around the heart halves to keep them in place. Smooth the joins where the arms connect to the body to create a seamless shape.

(continued)

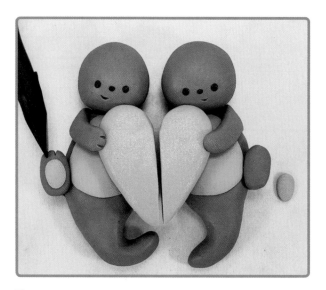

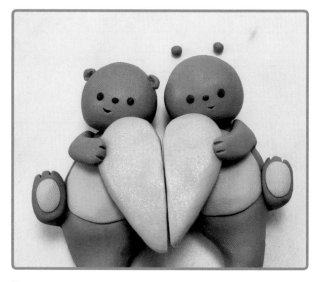

7. Take your two reserved pieces of tan clay and flatten them into slightly oblong disks. Affix those disks to the exposed bottoms of the feet to create foot pads. Use your chisel tip shaper to make small notches in the feet and hands to create the look of fingers and toes.

8. Take your remaining four pieces of brown clay and shape them into tiny, slightly flattened balls and put them on the side of the otters' heads, near the top, to create ears. Use your small ball stylus to add a small indent inside each ear to complete the look. Do a final shaping and smoothing to make sure everything looks right and fits together perfectly.

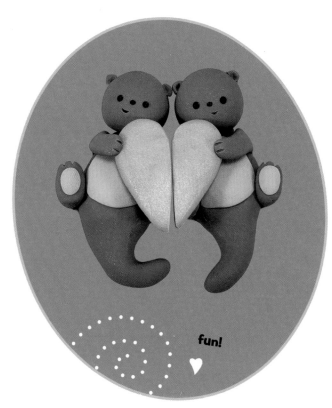

fun!

VARIATIONS

- Put a bow in the hair of one of the otters.
- Use your needle tool to add texture to the brown clay to simulate fur.
- Change the eye shape to be more serene.
- Change the heart color or use a different shape altogether.
- Pinch and shape a tiny piece of the head to create a little tuft of hair.

9. Bake the holder at 250°F (120°C) for 30 minutes. Allow to cool completely. After the entire piece has baked and cooled, affix the magnets with a tiny drop of E6000 or similar crafting glue. Allow the glue to fully dry and cure before use.

Cactus Tack Holder

This fun project is also useful! There are a few prickly little details to watch out for, but when you are done, everyone will be green with envy. Let's get to the main points!

Project time: 30 minutes

MATERIALS

Cactus: 3 sections Granny Smith (Sculpey #1629) completely mixed with ½ section Pearl (Sculpey #1101) and ¾ section Leaf Green (Sculpey #322)

Soil base: 2 sections Hazelnut (Sculpey #1657) completely mixed with ½ section Tan (Sculpey #301)

Blue rim: ½ section Pearl (Sculpey #1101) completely mixed with 2 sections Turquoise (Sculpey #505)

Balloon: 1 E-size piece Candy Pink (Sculpey #1142) completely mixed with 1 E-size piece Pearl (Sculpey #1101)

Faces: 2 A-size pieces Black (Sculpey #042) and 1 A-size piece Ballerina Pink (Sculpey #1209)

Two 2-inch-long (5 cm) 16-gauge round wires, for support

Liquid Sculpey Translucent

TOOLS

Roller

Medium ball stylus

Needle tool

Diamond tip tool

Tacks or pushpins

1. Condition your clay to make sure it's pliable and ready to work (see page 12). Roll each piece into a ball. Divide your brown ball into two balls, one about half the size of the other. Use your roller to flatten them out into disks about ¼ inch (6 mm) thick.

(continued)

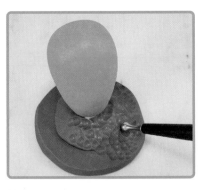

2. Divide your green clay into three pieces: two ½ sections for the arms and the remaining piece for the cactus body, which should be formed into a corn kernel shape. Similarly shape the arms like the cactus body but slightly curve them at the tapered ends

3. Stack the smaller brown disk onto the larger one. Slide one of your pieces of wire into the center of the two disks, making sure to pierce through both. Create a small indentation around the base of the wire for the tapered end of the cactus. Slide the cactus body, tapered end down, onto the wire piece and secure it to the base. Use a dot of Liquid Sculpey at the base to ensure a secure hold.

4. Use your medium ball stylus to press the top brown disk into the bottom brown disk and create an uneven texture to simulate soil.

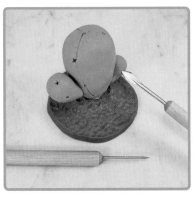

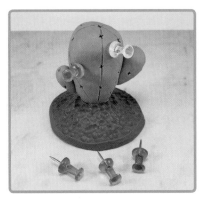

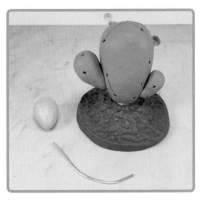

5. Attach the arms to the body of the cactus, pressing gently to make sure they are secured and smoothing out the joins to create a solid figure. Use your needle tool to etch long, vertical lines in the body and arms to simulate the section lines seen on cacti. Use your diamond tip tool to poke small Xs at various intervals along those vertical lines and on the arms to simulate the look of spines.

6. The Xs you poked in are made to hold tacks or pushpins. Make sure the holes are deep enough to accommodate them by using a pushpin itself to make the final indentation. Make sure you have enough room between the holes to be able to fit the pushpins next to each other.

7. Take your darker pink ball and work it into a smooth teardrop shape for the balloon. Slightly pinch the tapered end to simulate the balloon knot. Bend your remaining piece of wire into a slight curve.

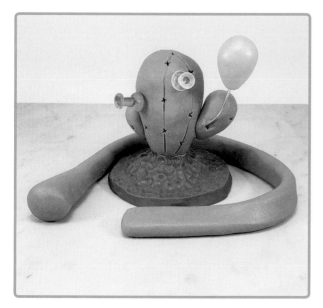

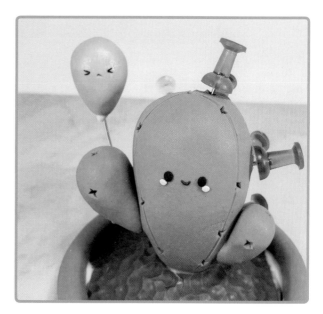

8. Attach the wire to the body of the cactus through the back of one of the arms, leaving a length of wire exposed at the top of the arm. Add a small dot of Liquid Sculpey to the top of the wire. Slide the balloon onto the top of the wire to make it look like the cactus is holding a balloon on a string. Roll out your ball of blue clay into a long, thick strand, about 8 inches (20 cm) long. Use your roller to slightly flatten it, and then wrap the strip of blue clay around the brown base to create a rim. Smooth out any seams.

9. Take your black clay and create a short line for the mouth of the cactus and four small disks for the eyes on the cactus and the balloon. Make sure that the faces are securely attached where you think they look best. Use your diamond tip tool to cut out a small notch for the mouth of the balloon. Use your light pink clay to create two small oblong disks. Attach them just below the eyes of the cactus to be "rosy" cheeks.

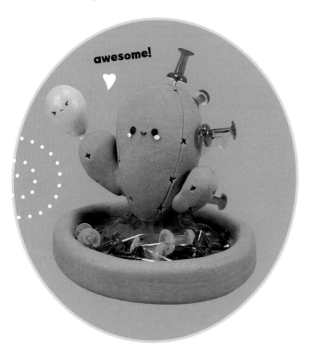

awesome!

VARIATIONS

- Change the balloon color, or add more balloons.
- Change the rim color.
- Put a bow tie or hat on the cactus.
- Change the face details.
- Put a flower on top of the cactus.
- Add some more details in the soil, such as a small snail or mushroom.

10. Remove all tacks. Bake the holder at 250°F (120°C) for 45 minutes. Allow to cool completely before using.

Unicorn Figurine

This adorable, little unicorn might look complicated to make, but if you just follow the steps carefully, it'll all come together like magic. Let's get started and you'll soon get the point!

Project time: 45 to 60 minutes

MATERIALS

Body: 1½ sections White (Sculpey #001) completely mixed with 1½ sections Pearl (Sculpey #1101)

Tummy: 1 E-size piece Ballerina Pink (Sculpey #1209)

Mane and tail: Divide 1 D-size piece Pearl (Sculpey #1101) into 4 equal pieces and completely mix a piece with each of the following: 1 D-size piece Purple (Sculpey #513) for purple, 1 D-size piece Candy Pink (Sculpey #1142) for pink, 1 D-size piece Turquoise (Sculpey #515) for blue, and 1 D-size piece Granny Smith (Sculpey #1629) for green

Pads: 1 E-size piece Silver (Sculpey #1130)

Horn: 1 C-size piece Candy Pink (Sculpey #1142) and 1 C-size piece White (Sculpey #001) lightly mixed to create a marbled effect

Face: 1 A-size piece Black (Sculpey #042)

Two 1½-inch-long (4 cm) eye pin shafts, for support

1 Lollipop Charm without the eye pin (page 34)

TOOLS

Roller

Medium ball stylus

Small ball stylus

1. Condition your clay to make sure it's pliable and ready to work (see page 12). Roll each piece into a ball. Pinch off two B-sizes pieces of the pearl ball to make the ears in step 7. Divide the remaining pearl ball into six pieces: ½ section for the head, two ¼ sections for the arms, two ¼ sections for the legs, and the remaining large piece for the body. Shape the head into a ball, the body into a slightly flattened, rounded triangle, and the legs and arms so that they're more tapered at the tops than the bottoms.

2. Using the roller, roll out your pink ball for the tummy, shape it, and fit it on the torso piece.

3. Attach the arms and legs to the torso and sit up the character, making sure the base is stable and flat. Shape the arms and legs to be a bit tapered at the shoulders and hips, with the hooves just slightly larger. Push an eye pin shaft partially down into the torso.

4. Push the head onto the exposed eye pin shaft, keeping the figure stable and upright. Use your medium ball stylus to create a small indentation in the top of the head for the horn to go into later.

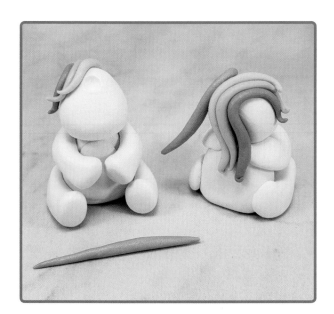

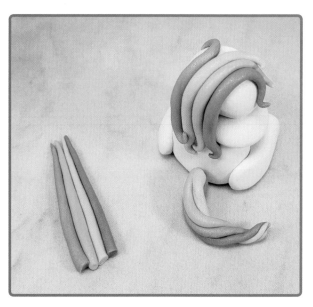

5. Roll out each of your individual mane and tail colored balls into two tapered strands each, about 2 inches (5 cm) long. Set one set of strands aside to use as the tail in the next step. Arrange the other set of strands as the mane, on and around the head, however you think it looks best (avoid the indentation where the horn will go and leave small spaces for the ears to be attached in step 7).

6. Create the tail by twisting the reserved strands together and placing them at the back base of the figure. Shape as you desire.

(continued)

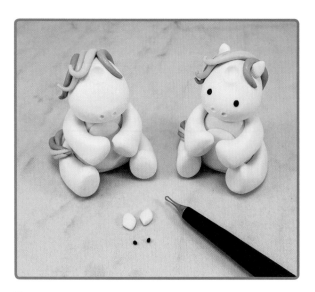

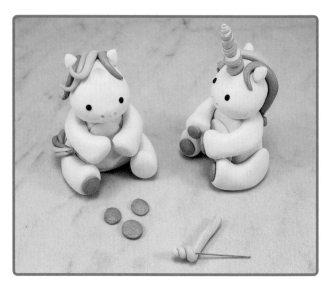

7. Using your small ball stylus, make small indentations for the unicorn's nostrils, and then use your black clay to to create two disks for the eyes. Place them on the face where you think they look best. Take the reserved piece of pearl clay and shape two small, pointy ears. Attach them to the head, being careful of the mane strands.

8. Divide your silver ball into four equal-size balls. Flatten those balls to create pads for the bottom of each hoof. Attach the hoof pads. Using the pink marbled clay, create a twisted horn shape and wrap it around the remaining eye pin shaft, leaving a bit of the pin exposed at the base. Attach the horn by pushing the eye pin shaft into the indentation you made in the head earlier.

9. Place the Lollipop Charm between the front hooves of the unicorn, being careful not to distort the pads or face.

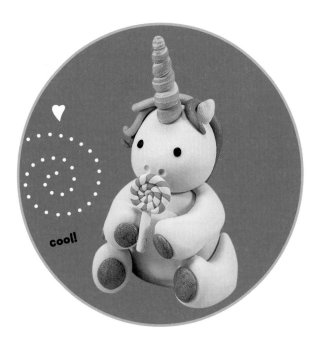

cool!

VARIATIONS

- Change the mane or horn colors.
- Add a different item instead of the lollipop.
- Create crazier or curlier mane and tail patterns.

10. Bake the unicorn at 250°F (120°C) for about 35 minutes, keeping a close eye on it near the end to make sure the lighter-colored clay doesn't begin to discolor. Allow to cool completely.

Resting Beach Face Sand Zen Garden

You might not reach nirvana working on this project, but you will have fun. I promise! There are quite a few pieces, but if you take your time and go step by step, you won't drown in the details. Let's dive in!

1. Condition your clay to make sure it's pliable and ready to work (see page 12). Roll each piece into a ball. Use your blue ball to create a simple whale shape (see steps 1 and 2 of the Whale Ring Holder on page 82). Use your curved carving tool to cut out a small mouth, and use a small pinch of black clay to create two small disks for the eyes, affixing them above the mouth. Don't forget the fins!

(continued)

Project time: 75 minutes

MATERIALS

Whale and spout: 1½ sections Light Blue Pearl (Sculpey #1657) and 1 C-size section White (Sculpey #001)

Crab: 1 F-size piece Sweet Potato (Sculpey #033)

Starfish: 1 D-size piece Pearl (Sculpey #1101) completely mixed with 1 D-size piece Fuchsia Pearl (Sculpey #1112)

Seashells: 1 D-size piece White (Sculpey #001) and 1 D-size piece Gentle Plum (Sculpey #355)

Squid rake: 1 F-size piece Granny Smith (Sculpey #1629) completely mixed with 1 F-size piece Pearl (Sculpey #1101); 1 A-size piece Cactus Green (2 mixed colors; see page 42 for recipe) for the dots

Faces: 1 B-size piece Black (Sculpey #042)

Five ½-inch-long (13 mm) eye pins

1 Sea Turtle Figurine (page 60)

6 × 8-inch (15 × 20 cm) shallow tray

28 ounces (794 g) decorative sand

TOOLS

Curved carving tool

Medium ball stylus

Chisel tip shaper

Small star-shaped cutter

Small ball stylus

Long eye pin

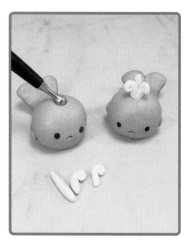

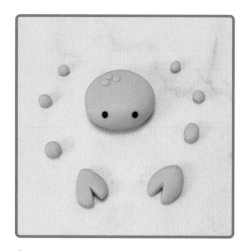

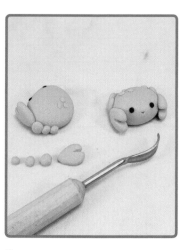

2. Divide the white ball for the spout into three ½-inch-long (13 mm) strips, tapered and curled at one end. Use your medium ball stylus to create a small indentation on the top of the whale as the blowhole. Arrange the white strips in the hole to simulate a spout of water.

3. Divide your orange ball into two B-size pieces shaped into teardrops for the claws, six tiny pinches rolled into balls for the arms, and the remainder shaped into a slightly flattened ball for the body of the crab. Use a small pinch of your black clay to create two small disks for eyes and affix them to the front of the main body. Use your chisel tip shaper to cut out the notches in the claws.

4. Affix the claws to each side of the main body, and then affix the small balls behind the claws to create the arms. Use your curved carving tool to cut out a small mouth beneath the eyes.

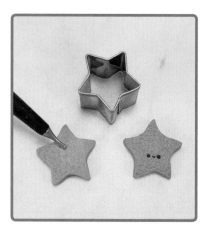

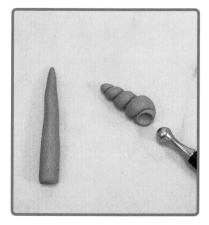

5. Flatten your pink ball into a small disk. Use your star cutter tool to cut out a star shape. Use your small ball stylus to create a textured pattern on the starfish. Use a small pinch of your black clay to create a short line for the mouth and two small disks for the eyes and affix accordingly.

6. Work your remaining white ball into two rounded triangular shapes. Use your long eye pin to create vertical lines to simulate the look of a seashell.

7. Roll out your plum ball into two short, tapered strands. Holding the thicker end, twist each strand onto itself to create two spiral shell shapes. Use your medium ball stylus to create small indentations on the thicker ends to complete the look of empty shells.

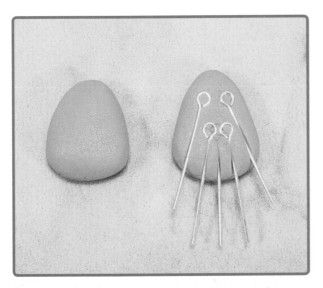

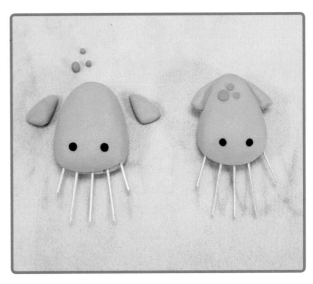

8. Divide your lighter green ball into two equal-size pieces for the body of the squid, but first set aside two small pinches of this clay to be used as the squid's details in the next step. Shape the body pieces into slightly flattened, rounded triangles. Turn one piece over to expose the flattened underside and use the five eye pins to create a rake, placing them at various lengths along the bottom edge, with the shafts sticking out the bottom as the "tines" of the rake. Cover this piece with the matching body piece and press together to create the full body shape.

9. Work the two small pinches of lighter green clay into two rounded triangular shapes. Slightly flatten them and then attach them near the top of the squid. Use your darker green clay to add a few small dots to the top of the head. Use a small pinch of your black clay to create two small disks for the eyes. Affix the eyes where you think they look best.

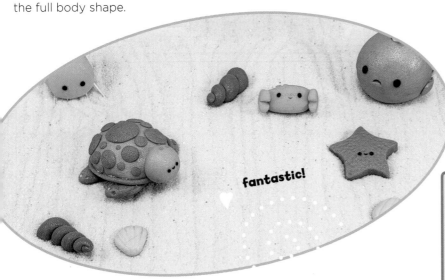

fantastic!

10. Bake the whale at 250°F (120°C) for 25 minutes. Bake all of the other pieces at 275°F (135°C) for 15 minutes. Allow to cool completely. Pour sand into your shallow tray, and then arrange the individual figures on the sand. Use the squid rake to smooth out the sand for a Zen garden experience.

VARIATIONS

- Add some new characters such as a sunken boat or a treasure chest.

- Use colored sand to create a more undersea look.

Mountain Scene Votive Candle Holder

This project is the peak of cuteness and will light up your life. Don't worry, it's not a difficult hill to climb, and I'll help you see the forest for the trees. Here are the details you're pining for!

Project time: 45 minutes

MATERIALS

Sky backdrop: 2 whole bricks Light Blue Pearl (Sculpey #1103)

Mountain: 2 sections Elephant Gray (Sculpey #1645)

Snowcap: 1 F-size piece White (Sculpey #001)

Tree bottoms: 1 F-size piece Leaf Green (Sculpey #322)

Tree middles: 1 E-size piece Leaf Green (Sculpey #322) completely mixed with 1 C-size piece Pearl (Sculpey #1101)

Treetops: 1 D-size piece Leaf Green (Sculpey #322) completely mixed with 1 D-size piece Pearl (Sculpey #1101)

Tree trunks: 1 E-size piece Hazelnut (Sculpey #1657)

Faces: 1 C-size piece Black (Sculpey #042)

Liquid Sculpey Translucent

1 votive candle or flameless alternative

TOOLS

8 x 10-inch (20 x 25 cm) piece parchment paper

Roller

Straightedge or ruler

Craft blade or knife

Small star-shape cutter

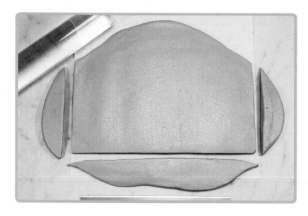

1. Condition your clay to make sure it's pliable and ready to work (see page 12). Roll each piece into a ball. Flatten your blue ball into a disk. Lay your parchment paper on your work surface and put the disk on top of it. Use your roller to roll out the disk into a large, flat disk, ⅛ inch (3 mm) thick. Use your straightedge and craft blade to trim and square off the bottom, left, and right sides. Leave the top edge untrimmed, but smooth it out to make sure it's flat and even along the whole edge. This piece should be 5½ inches (14 cm) wide and 4 inches (10 cm) tall at the top of the rounded edge. Set this piece aside, leaving it on top of the parchment paper.

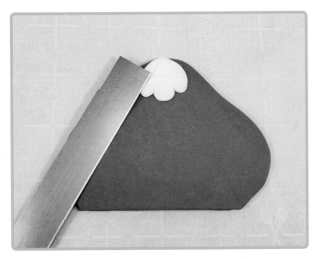

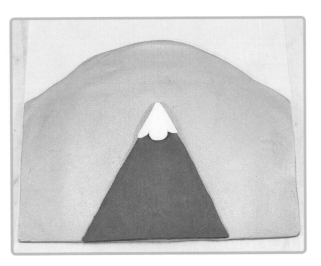

2. Pinch two small pieces off your gray ball to use as the arms around the trees in step 6. Work the remaining gray ball into a cone shape. Use your roller to flatten the cone into a smooth, even, flat surface, again about ⅛ inch (3 mm) thick. Flatten your white ball and create a slightly rounded shape with a few scalloped details along the edge to simulate the look of drifting snow. Place it at the peak of your gray mountain. Use your straightedge and craft blade to trim the bottom and sides into a triangle with a white cap.

3. Arrange your mountain on the blue background. Use a few drops of Liquid Sculpey to ensure a secure hold. Set aside, still leaving the clay on the parchment paper.

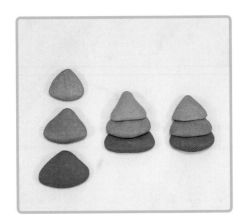

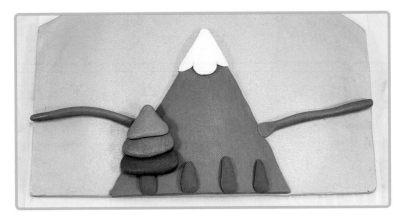

4. Divide each green ball into four equal-size pieces. Create slightly squashed teardrop shapes, with the darkest green pieces being the widest, working up to the light green pieces being the narrowest and with more pronounced peaks. Arrange the green clay pieces, starting with the darkest on the bottom, and then layer the other shades of green on top.

5. Divide your brown ball into four short, oblong pieces to be the tree trunks. Place the trunks on the front of the mountain, leaving enough space between them so the trees will fit with minimal overlap. Roll out the reserved pieces of gray clay into two long strands, about 3 inches (7.5 cm) long. Attach them to the sides of the mountain as long arms. Do not press them into the blue background. Add the trees to the top of the trunks and arrange accordingly. Use some Liquid Sculpey as adhesive to ensure the trees are firmly affixed.

(continued)

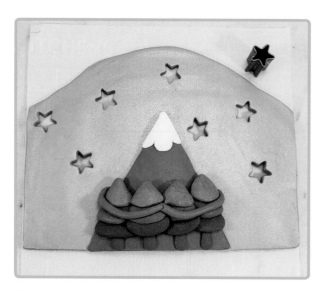

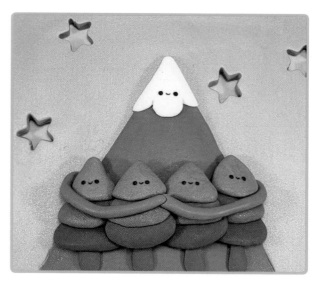

6. Wrap the gray clay arms around the trees, hugging them. Use a few drops of Liquid Sculpey to keep everything secure, if necessary. Use your star-shaped cutter to stamp out a few stars on the blue background.

7. Use your black clay to create face details for the snowcap and trees. Apply the face details, making sure they are secure because the piece will eventually be standing vertically.

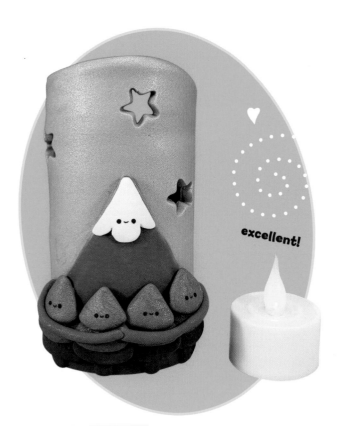

excellent!

VARIATIONS

- Add a few details in the sky, like clouds or birds, or cut out a moon shape.
- Change the face details or use your curved carving tool to create an open-mouth effect.
- Add a few woodland creatures to the bottom of the scene.

8. Carefully move your parchment paper to your baking tray. Slowly and carefully stand up your sheet of clay, and using the parchment to maneuver it, curve the sheet onto itself to make a vertically standing tube. Join the ends and use your fingers to smooth out the seam. Carefully remove the parchment paper after the tube is standing solidly. Very carefully put the tray with the standing clay tube into the oven. (Tip! You can leave the parchment paper on until after baking if it's easier to handle it.) Bake at 250°F (120°C) for 30 minutes. Allow it to cool completely. Put a votive candle (or flameless alternative) into the center to enjoy a warm glow.

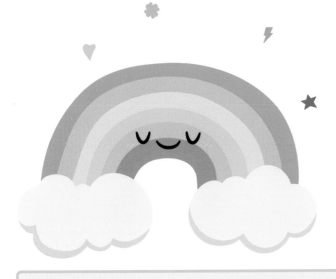

Rainbow Soap Dish

If you want to add a little color next to your sink, make this bright soap holder! I'm ready to dish all the details you need.

Project time: 30 minutes

MATERIALS

Rainbow: 2 sections Teal Pearl (Sculpey #538) for teal; 1 section Fuchsia Pearl (Sculpey #1112) completely mixed with 1 Section Pearl (Sculpey #1101) for pink; 1 section Sweet Potato (Sculpey #033) completely mixed with 1 section Pearl (Sculpey #1101) for orange; 1 section Yellow (Sculpey #072) completely mixed with 1 section Pearl (Sculpey #1101) for yellow; 1 section Turquoise (Sculpey #505) completely mixed with 1 section Pearl (Sculpey #1101) for blue; and 1 section Purple (Sculpey #513) completely mixed with 1 section Pearl (Sculpey #1101) for purple

Blue clouds: 1½ sections Light Blue Pearl (Sculpey #1103)

White clouds: 1 section White (Sculpey #001)

Sun: ½ section Yellow (Sculpey #072)

Raindrops: 1 F-size piece Turquoise (Sculpey #505)

Faces: 1 B-size piece Black (Sculpey #042) and 1 pinch Ballerina Pink (Sculpey #1209)

Six ½-inch-long (13 cm) eye pin shafts, for support

Liquid Sculpey Translucent

TOOLS

8 × 10-inch (20 × 25 cm) piece parchment paper

Roller

5- to 6-inch (12.5 cm to 15 cm) oven-safe round plate or dish (see step 2 on page 110)

Craft blade or knife

1. Condition your clay to make sure it's pliable and ready to work (see page 12). Roll each piece into a ball. Roll the balls for your rainbow into long, thick strands, about 5 inches (12.5 cm) long and the same width if possible. Arrange your colored strands on the parchment paper, making sure the strands are lightly pressed together in the order of the rainbow. Use your roller to roll out the strands of color into a flat sheet, about ¼ inch (6 mm) thick and approximately the size of the parchment paper. Leave it on the parchment paper for now.

(continued)

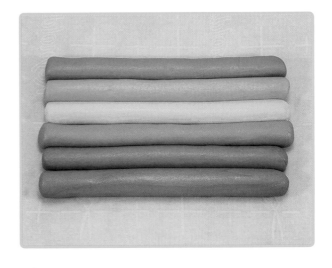

2. Your oven-safe plate or dish should be just slightly smaller than your rainbow sheet. This dish will be the base that the rainbow dish will bake on, to give it the right shape. After baking, the plate can be removed from the finished polymer-clay soap dish.

3. Flip your parchment paper over onto the plate so that the clay is facing down. Slowly peel away the parchment to leave just the smooth clay underneath on top of the oven-safe dish. Make sure the rainbow sheet completely covers the dish with some overhang after the sheet has fully molded itself to the dish. Use your roller to go over the edges and lip of the dish to lightly press it to the rim while cutting off any excess.

4. Use your craft blade to clean up the edges and make sure the whole surface is flat and smooth. Create any small details you want on the lip of the dish at this point, like a scalloped edge or a slightly raised lip on the rim.

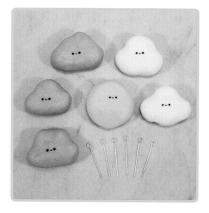

5. Divide your blue ball into three equal-size pieces and your white ball into two equal-size pieces. Shape the clouds however you think they look best. Create a small disk with the yellow ball for the sun.

6. Use your black clay to create face details for the clouds and sun. Affix the faces where you think they look best. Use your pink clay to create small dots for rosy cheeks on the white clouds. Affix accordingly.

7. Before attaching the sun and clouds with the eye pins, carefully arrange them the way you think they look best on the rainbow dish. Once you have a plan, remove the items and poke an eye pin shaft into the soap dish wherever you want to put one of the figures. Add a small drop of Liquid Sculpey to the base of each pin before sliding the sun or a cloud onto it.

8. Divide your turquoise ball into several small balls. Form them into raindrop shapes. Add a small dot of Liquid Sculpey to the underside of each drop and place on the dish in whatever rain pattern looks best to you.

VARIATIONS

- Add some gray storm clouds.
- Change the face details, or use your curved carving tool to create an open-mouth effect.
- Change the shape of the dish so it has a sloped edge on the front for drainage.
- Omit the raindrops and use as a candy dish instead.

great!

9. Bake at 250°F (120°C) for 45 minutes, rotating the dish halfway through. Watch to make sure the white clay doesn't discolor too much. Allow it to cool completely. As the piece bakes and cools, it will pull away from the dish, allowing you to remove the dish after the whole piece is cool. Polymer clay is virtually waterproof, so this works well as a soap holder and can be rinsed off easily.

When Pigs Fly Mobile

This might look like a lot to handle, but if you follow each step, you'll be flying in no time. Don't worry, I'd never leave you hanging. Let's get makin' some bacon!

Project time: 75 minutes

MATERIALS

Pigs: 1½ sections Ballerina Pink (Sculpey #1209)

Wings: 1 F-size section White (Sculpey #001)

Moon: 2 F-size pieces Silver (Sculpey #1130)

Sun: 2 F-size pieces Yellow (Sculpey #072)

White clouds: 2 E-size pieces White (Sculpey #001) and 1 pinch Ballerina Pink (Sculpey #1209)

Blue clouds: 2 E-size pieces Light Blue Pearl (Sculpey #1103) and 1 C-size piece Blue (Sculpey #063)

Gray storm cloud: 2 E-size pieces Silver (Sculpey #1130), 1 pinch Blue (Sculpey #063), and 1 B-size piece Yellow (Sculpey #063)

Rainbows: 1 D-size piece Candy Pink (Sculpey #1142) completely mixed with 1 F-size piece Pearl (Sculpey #1101) for pink; 1 D-size piece Teal Pearl (Sculpey #538) completely mixed with 1 F-size piece Pearl (Sculpey #1101) for teal blue; 1 D-size piece Purple (Sculpey #513) completely mixed with 1 F-size piece Pearl (Sculpey #1101) for purple; and 1 F-size piece Lemonade (Sculpey #1150) completely mixed with 1 D-size piece Pearl (Sculpey #1101) for yellow

Faces: 1 C-size piece Black (Sculpey #042) and 2 A-size pieces Ballerina Pink (Sculpey #1209)

Liquid Sculpey Translucent

Twelve ½-inch-long (13 mm) eye pins

4-inch (10 cm) embroidery hoop

3- to 4-feet (0.9 to 1.2 m) string or fishing line

TOOLS

Smooth, slender tube, such as the barrel of a pen or a tool handle

Small ball stylus

Chisel tip shaper

Craft blade or knife

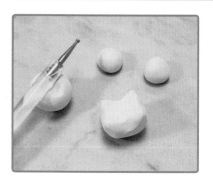

1. Condition your clay to make sure it's pliable and ready to work (see page 12). Roll each piece into a ball. Divide your light pink ball for the pigs into three equal-size balls. Each ball will be a pig. Take one ball and divide it into three A-size pieces for the ears and tail, a B-size piece for the nose, an E-size piece for the head, and the remaining large piece for the body. Set aside the ears, tail, and nose for the next step. Shape the body with the smooth side of a pen or one of your tools to create the desired piggy shape with stubby little legs, a rounded backside, and a belly. Roll the head into a smooth ball with a slightly flattened bottom. Repeat for the other two pigs.

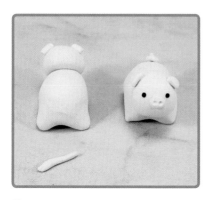

2. Affix the head to the body of the pig, making sure it's firmly secured. Take your reserved pinches of pink clay and form slightly flattened, rounded triangles for the ears and a small, oblong disk for the nose. Roll out the last piece of pink clay into a short strand. Attach it to the pig's behind and twist it to create a small corkscrew tail. Use a pinch of your black clay to create two small disks for the eyes, and affix them to the head. Use your small ball stylus to make two small nostril indentations into the nose. Repeat for the other two pigs.

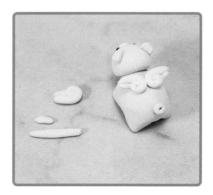

3. Take two small pinches of the white ball for the wings and roll them out into short strands. Pinch off a small piece of the end of one strand and double it up against one end of the strand. Curl the strand around the small piece to create a small swoop effect. Repeat to create a second "wing." Affix them to the back of the pig. Repeat for the other two pigs.

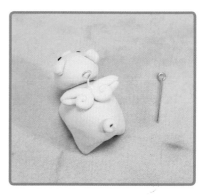

4. Put a small drop of Liquid Sculpey on the tip of one of your eye pins. Slide the eye pin into the back of the pig between the wings, leaving the eye exposed. Repeat for the other two pigs.

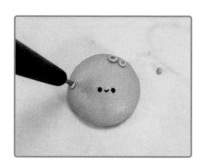

5. Pinch off a couple of tiny pieces of your silver ball, and then slightly flatten the remaining silver ball into a rounded disk for the moon. Put a small drop of Liquid Sculpey on the tip of one of your eye pins. Slide an eye pin into the top of the moon, leaving the eye exposed. Place the small pieces you pinched off earlier on the face of the moon as small dots. Use your small ball stylus to press a small indentation into the dots to create a crater-like effect. Use a small pinch of your black clay to create a short line for the mouth and two small disks for the eyes. Apply them to the face of the moon accordingly.

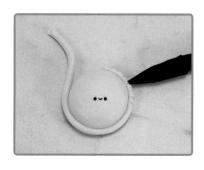

6. Pinch off one-fifth of your yellow ball and roll it into a thin strand, about 3 inches (7.5 cm) long. Press the remaining yellow ball into a slightly flattened, rounded disk. Use a small pinch of black clay to create a short line for the mouth and two small disks for the eyes. Apply them to the face of the sun. Wrap the long strand of yellow clay around the disk and smooth out the join. Use your chisel tip shaper to etch a notched pattern into the strip around the entire sun. Put a small drop of Liquid Sculpey on the tip of one of your eye pins and slide the eye pin into the top of the sun, leaving the eye exposed.

(continued)

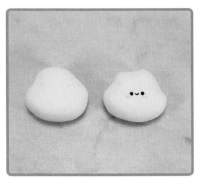

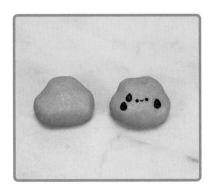

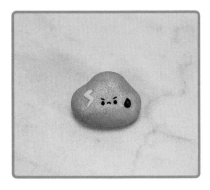

7. Divide your white ball for the clouds into two equal-size pieces. Form each piece into a cloud shape. Use a couple pinches of black clay to create short lines for the mouths and small disks for the eyes. With the remaining light pink clay, create small disks for the clouds' "rosy" cheeks. Add the face details to the clouds. Put a small drop of Liquid Sculpey on the tips of two eye pins. Slide an eye pin into the top of each cloud, leaving the eye exposed.

8. Repeat step 7, but with the lighter blue ball. After adding the face details, take your dark blue clay and divide it into three small balls. Shape them into raindrops and affix them to the blue rain clouds. Put a small drop of Liquid Sculpey onto the tips of two eye pins. Slide an eye pin into the top of each cloud, leaving the eye exposed.

9. Repeat step 7, but with the remaining silver ball. Add one raindrop with the blue clay. Use your yellow clay to create a small lightning-bolt shape and add it to the face of the gray storm cloud. Put a small drop of Liquid Sculpey on the tip of one of your eye pins. Slide the eye pin into the top of the cloud, leaving the eye exposed.

10. Roll out the remaining colored pieces of clay into thin rods, about 2 to 3 inches (5 to 7.5 cm) long. Create a U-shape with the shortest piece, and keep repeating that U-shape with each color, pressing them together slightly to ensure they are securely affixed. After all the colors are in place, use your craft blade to trim and square off the ends. Repeat to make a second rainbow. Put a small drop of Liquid Sculpey on the tips of two eye pins. Slide an eye pin into the top of each rainbow, leaving the eye exposed.

super!

11. Bake all the individual pieces at 275°F (135°C) for 15 minutes. Keep an eye on them to make sure the lighter pieces don't discolor too much. Allow to cool completely. Assemble your mobile by tying varying lengths of the string or fishing line to the eye pins, and then tying the other ends of the string to the embroidery hoop, making sure to try and keep the entire mobile balanced so it hangs straight. You can adjust both the lengths of the strings and the placement of the ties to achieve your desired effect.

VARIATIONS

• Add some new characters, such as birds or planets.

• Change the face details on any or all of the characters.

• Use Sculpey glow-in-the-dark clay for some details to create a cool effect.

Fairy Garden

This project is perfect nestled beside your favorite plants. When guests see it, they'll realize there really is no place like gnome. Let's get this growing!

Project time: 75 minutes

MATERIALS

Mushroom house base; small mushroom stems; snail body; and gnome head, nose, and hands: 1 section Pearl (Sculpey #1101) completely mixed with 1 D-size piece Tan (Sculpey #301)

Mushroom house door and trim, gnome belt and shoes, and beehive opening: 1 F-size piece Hazelnut (Sculpey #1657)

Mushroom house cap: 1 section Gentle Plum (Sculpey #355)

Gnome beard and bee wings: 1 F-size piece White (Sculpey #001)

Stones: 1 F-size piece Elephant Gray (Sculpey #1645) lightly mixed with 1 F-size piece Silver (Sculpey #1130) to create a marbled effect

Doorknob, faces and bee details: 1 C-size piece Black clay (Sculpey #042)

Small mushroom caps: 1 D-size piece Pearl (Sculpey #1101) divided into 4 equal-size pieces and completely mixed with 1 B-size piece Granny Smith (Sculpey #1629) for the green cap, 1 A-size piece Light Blue Pearl (Sculpey #1103) for the blue cap, 1 A-size piece Fuchsia Pearl (Sculpey #1112) for the pink cap, and 1 A-size piece Lemonade (Sculpey #1150) for the yellow cap

Snail shell: 1 B-size piece Fuchsia Pearl (Sculpey #1112) completely mixed with 1 B-size piece Pearl (Sculpey #1101)

Gnome hat and pants: 1 E-size piece Turquoise (Sculpey #505)

Gnome body and arms: 1 C-size piece Light Blue Pearl (Sculpey #1103)

Beehive: 1 D-size piece Lemonade (Sculpey #1150)

2-inch-long (5 cm) eye pin shaft, for support

Six 1½-inch-long (4 cm) eye pin shafts, for support

Liquid Sculpey Pearl

½-inch-long (13 mm) eye pin

3-inch-long (7.5 cm) 16-gauge round wire, for hanging the beehive

TOOLS

Long eye pin

Medium ball stylus

Small ball stylus

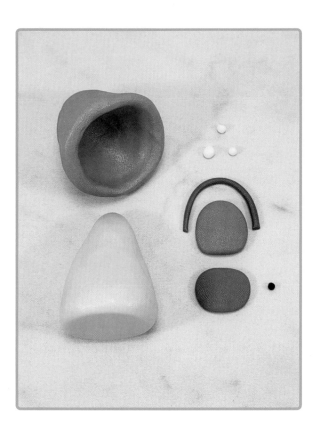

1. Condition your clay to make sure it's pliable and ready to work (see page 12). Roll each piece into a ball. Separate out six B-size and three A-size pieces from your tan ball and set aside. Separate out four A-size pieces from your brown ball and set aside. Shape the remaining tan clay into a rounded cone, pressing the blunt end against your work surface to create a flat, stable base. Form your plum ball into another cone shape, slightly wider and flatter than the tan one. Use your fingers to create a deep indentation in the blunt end of this cone. Divide your remaining brown clay into two pieces, with one making up two-thirds of the amount and the other one-third. Shape the larger piece into a slightly flattened and rounded oblong shape for the door. Roll the smaller piece into a thin strand, about 2 inches (5 cm) long, for the trim. Take a generous pinch from the white ball and divide it into six to eight small balls. Flatten into disks and place as the dots on the mushroom house cap. Take a D-size piece of marbled gray clay to use as a stone landing. Form it into a ball before flattening it into a rounded disk, about the same width as the door. Roll a tiny pinch of black clay into a ball for the doorknob.

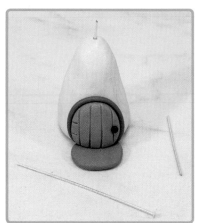

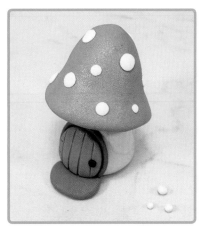

2. Affix the door and trim to the base of the mushroom house. Add your small piece of gray clay to the front as a stone landing. Use your long eye pin to create vertical-line details to simulate wooden planks on the door. Add the doorknob. Insert the 2-inch-long (5 cm) eye pin shaft into the top of the figure for support, leaving a length exposed

3. Place the plum cap onto the top of the base, sliding it over the eye pin post. Arrange the cap so it looks like the top of a mushroom. Flatten the small dots of white clay you set aside earlier into disks. Press those disks onto the cap to create the spots.

4. Divide the marbled gray clay into six to eight balls of various sizes, and then slightly flatten them into rounded disks to create stone-like shapes.

(continued)

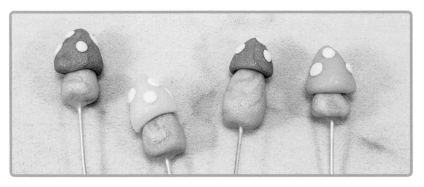

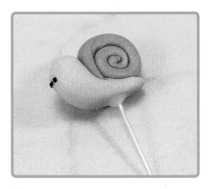

5. Take four B-size pieces of the reserved tan clay and form them into stubby cone shapes for the small mushroom stems. Setting aside a small pinch of the yellow clay, shape the balls for the caps into rounded cones, creating slight indents at their bases. Affix the caps to the stems. Take another generous pinch from the white clay and divide it into twenty tiny balls. Flatten into disks and place as the dots on the caps. Apply a small dot of Liquid Sculpey to the tips of four of the eye pin shafts, and then gently slide each one into the base of the mushroom stems.

6. Make a slightly smaller version of the Snail Figurine without antennae (page 24) with a B-size piece of the reserved tan clay and the pink clay for the snail shell. Apply a small dot of Liquid Sculpey to the tip of an eye pin shaft, and then gently slide that end into the bottom of the snail.

7. Divide your dark turquoise ball into two pieces. Shape the legs by creating a short rod and then curving it over until it creates an upside-down U shape. The hat is a simple cone. Divide your light blue ball into three pieces, a larger piece and two pinches. Shape the body into a rounded triangle and the arms into small teardrops. Take the remaining B-size piece of tan clay and shape it into a ball for the head. With the remaining three A-size pieces of tan clay, form them into balls for the nose and hands. Shape two of the reserved A-size pieces of brown clay into ovals for the shoes and another brown A-size piece into a thin strand, about 1½ inches (4 cm) long, for the belt. Pinch off two small pieces from the white clay and set them aside. Form the remaining white clay into a flattened oval shape for the beard.

8. Starting with the shoes, begin assembling the gnome, until you have the whole body firmly connected. Use your medium ball stylus to hollow out the bottom of the hat.

9. Attach the hat to the head, and attach the head to the body. Use a pinch of black clay to create two disks for the eyes and attach them. Affix the beard. Attach the hands to the arms, and then attach the arms to the body. Add the nose where the top of the beard meets the face. Once the gnome is shaped as you like it, slide the remaining eye pin shaft up through the bottom of the figure, adding a small drop of Liquid Sculpey around the base of the pin.

10. Divide your yellow ball into two pieces. Shape one into an oblong base and the other into a thin strand, about 2 inches (5 cm) long. Wrap the strand around the oblong base piece to create a beehive effect.

11. Slide the eye pin into the top of the hive, using a small drop of Liquid Sculpey aound the exposed end. Form the remaining brown clay into a small disk and gently press a small disk of darker brown clay and gently press onto the bottom third of the hive. Use your small ball stylus to create a deep indentation in that disk, to simulate the opening of the hive.

12. Take a small pinch of the reserved lighter yellow clay and create a tiny disk. Take two tiny pinches of black clay and roll them out into two thin strands. Apply the strands to the small yellow disk to make the body of a bee. Affix the bee to the hive. Take the reserved pinches of white clay and form them into triangular shapes with rounded edges. These are the bee's wings. Affix them to the back of the bee body.

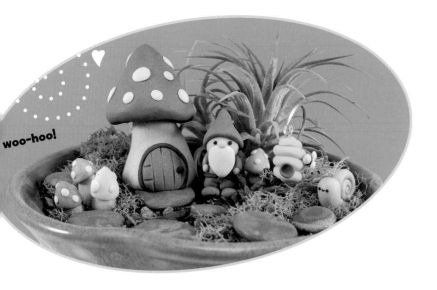

woo-hoo!

13. Bake the large mushroom house by itself at 250ºF (120°C) for 30 minutes. Then bake the other pieces at 275°F (135°C) for 15 minutes. Allow everything to cool completely. Arrange the various pieces in an existing flower or plant pot. Use some moss to complete the look. Use your length of 16-gauge wire to create a hook to hang the beehive from.

VARIATIONS

- Add some new characters such as turtles or more snails made from different colors.
- Get a dedicated container for the whole set and add your own succulents and other plants.
- Add a partner for the gnome!

- Add a window by putting a "wood" frame around some Sculpey glow-in-the-dark clay, and watch the scene glow at night.
- Do the same for the mini mushrooms or the spots.

Robot Paper Clip Holder

Beep-boop! This project isn't quite automatic, but after it's done, everyone will think you're magic! Making this mini metal marvel is easy and fun if you just follow the production line. Here we go!

Project time: 40 minutes

MATERIALS

Robot and boxes: 1 full brick Silver (Sculpey #1130)

Soil for cactus: 1 E-size piece Hazelnut (Sculpey #1657)

Robot heart and antenna: 1 C-size piece Turquoise (Sculpey #505)

Cactus and leaf: 1 F-size piece Cactus Green (2 mixed colors; see page 42 for recipe)

Cactus flower: 1 A-size piece Fuchsia Pearl (Sculpey #1112)

Faces: 1 A-size piece Black (Sculpey #042)

Twenty ¼-inch-long (6 cm) headpins, for support (you may use less)

Three 1-inch-long (2.5 cm) eye pin shafts

1 paper clip, for decoration, plus more for storing

Liquid Sculpey Translucent

TOOLS

Roller

Craft blade or knife

Small ball stylus

Long eye pin

Diamond tip tool

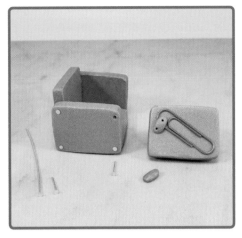

1. Condition your clay to make sure it's pliable and ready to work (see page 12). Roll each piece into a ball. Set aside two A-size pieces of silver clay. Divide your remaining silver clay into two portions, one being two-thirds of the piece and the other one-third. Using your roller, roll out the larger piece until it's about ¼-inch (6 mm) thick. Use your craft blade to trim and square off the edges, and then cut it into a series of squares and rectangles, all made to fit together to form two boxes attached to each other. Cut out four small squares for the small box (it will only have three sides), and one larger square with four larger rectangles for the big box. Slightly round the edges to give it a friendlier and more handmade appearance.

2. Use the reserved A-size pieces of silver clay to secure a paper clip to the front side of the larger box. Using headpins as supports, put the silver boxes together by sliding the pin shafts into the side of one piece and then using the exposed pin to secure it to another piece. Place these at the corners to create the boxes. Leave the front side of the small box open at this point.

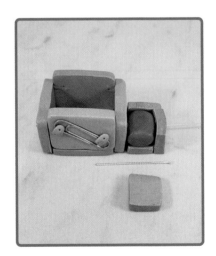

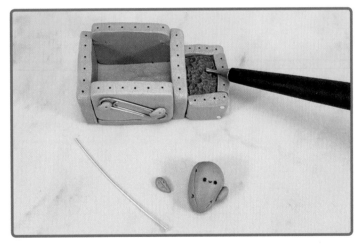

3. Before completing the smaller box, fill it with your brown ball, which should be shaped like a fat Tootsie Roll. Finish constructing your box, making sure it's secure, that the tops are fairly even, and that the boxes sit on a stable, flat base.

4. Use your small ball stylus to create a rough texture in the top of the brown clay. Use your long eye pin to add details, like rivets and lines, to the boxes. Pinch off a small piece of green clay and set aside. Shape your remaining green ball into a cactus (see Cactus Charm project on page 42 for details). Use some of your black clay to make a short line for the mouth and two small disks for the eyes, and apply carefully to the cactus. Shape the pinch of green clay into a leaf, using the long eye pin for details.

(continued)

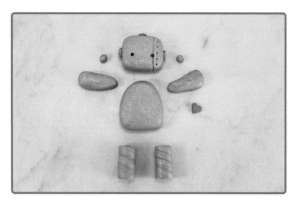

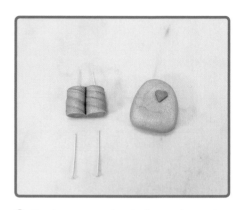

5. Take your remaining silver clay and divide it into eight pieces: an F-size piece for the robot's body, an E-size piece for the head, four C-size pieces for the arms and legs, and two small pinches for the ears. Shape the body into a rounded triangle, the head into a rectangle, the legs into thick, twisted rods, the arms into long teardrops, and the ears into balls. Divide your small piece of turquoise clay into two A-size pieces. Form one piece into a small, flat, rounded cone shape, and then use your wedge tool to cut a small wedge out of it to create a heart. Form the other piece into a ball, and then slightly flatten it on the top of the robot's head. Use your long eye pin to make face details, like rivets and lines, on the robot's head.

6. Push an eye pin shaft up through the bottom of each of the legs so that a portion sticks out at the tops. Use those posts to affix the legs to the body. Press the heart onto the chest of the robot.

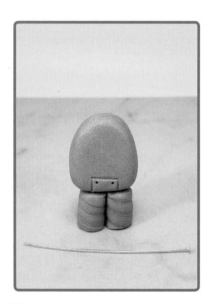

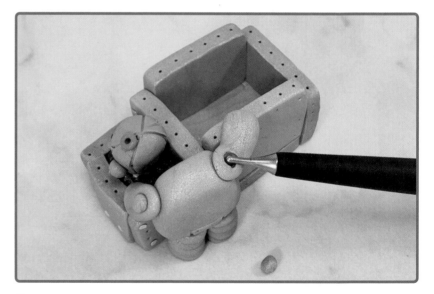

7. Use your long eye pin to create interesting details on your robot body, like access panels, switches, etc. I made a rear access panel for mine.

8. Place the robot behind the boxes and attach the arms so they are resting on the boxes. Use your small ball stylus to create rivet and bolt details on the arms and to help affix the arms to the boxes and the robot body. Use a small amount of Liquid Sculpey where the arms touch the boxes to ensure a good grip. Add the cactus to the top of the brown textured "dirt" in the smaller box, securing it with a small drop of Liquid Sculpey. Add your fuchsia ball as a flower to the top of the cactus (see Cactus Charm project on page 42).

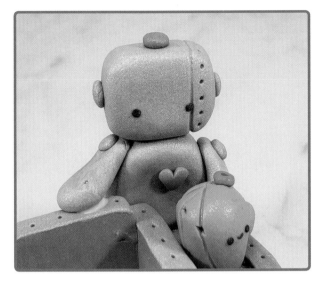

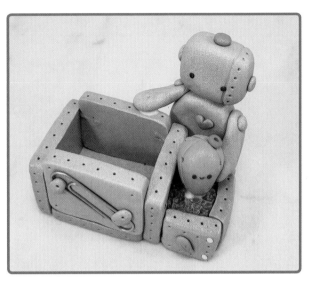

9. Attach the head of the robot, pressing down gently to make sure it's secure and stable. Use a small piece of eye pin shaft, if needed, to anchor it to the body.

10. Affix the leaf to the front of the small box. Use your long eye pin to add any additional details. Make sure the entire thing sits flat and stable on your work surface. Adjust accordningly. Make any other final adjustments.

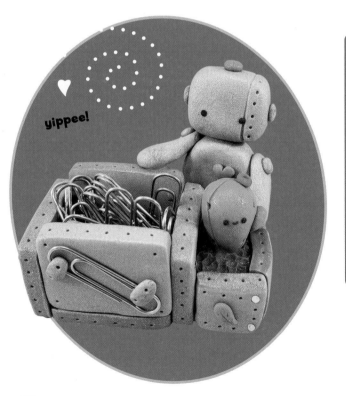

yippee!

VARIATIONS

• Change the faces.

• Use the opening for a small succulent plant or cactus.

• Change the front decoration.

• Add colorful details like buttons, switches, etc.

• Add another character, such as a bird or a ladybug.

11. Bake the holder at 275°F (135°C) for 25 minutes. Allow to cool completely before using. Finish by adding the paperclips.

Loch Ness Candy Dish

This sweet project might look like it's got a lot going on under the surface, but it'll go swimmingly. And that's no myth! Let's take a deep dive.

Project time: 40 minutes

MATERIALS

Bowl: 1 brick Blue (Sculpey #063), 2 sections White (Sculpey #001), and 1 section Light Blue Pearl (Sculpey #1103) folded together and lightly mixed until the clay takes on a marbled, ocean-like look (don't overmix)

Nessie head, body, and tail: 3 sections Teal (Sculpey #538)

Nessie chest and throat: 1 D-size piece Teal (Sculpey #538) completely mixed with 1 D-size piece Pearl (Sculpey #1101)

Hat main: 1 F-size piece Purple (Sculpey #513) completely mixed with ½ section Pearl (Sculpey #1101)

Scarf and hat trim: 1 C-size piece Purple (Sculpey #513) completely mixed with ½ section Pearl (Sculpey #1101)

White hat pom-pom: 1 B-size piece White (Sculpey #001)

Eyes: 1 A-size piece Black (Sculpey #042)

Crests: 2 A-size pieces Blue (Scupey #063)

1-inch-long (2.5 cm) eye pin shaft, for support

1½-inch-long (4 cm) eye pin shaft, for support

½-inch-long (13 mm) eye pin shaft, for support

Liquid Sculpey Pearl

Candy

TOOLS

Roller

4-inch (10 cm) oven-safe bowl (see step 2, opposite)

Craft blade or knife

Diamond tip tool

Small ball stylus

Needle tool

Small piece parchment paper

1. Condition your clay to make sure it's pliable and ready to work (see page 12). Roll each piece into a ball. Flatten your marbled blue ball into a round disk. Use your roller to roll it out into a large, flat round shape about ⅛ inch (3 mm) thick.

2. Your bowl will serve as a mold for your thin disk of marbled clay. It should be oven-safe and at least 3 inches (7.5 cm) deep. A glass bowl or a deep dish works great.

3. Mold your marbled disk onto the bowl. Make sure you press it deep enough that the sides of the clay disk can be turned up into a bowl, but still maintain a somewhat flat bottom in the middle.

4. Pinch four corners on the blue disk once it's well placed on the bowl, to create a slightly wavy surface along the rim, raised to a higher point, making sure you have pinched enough clay to create a deeper, steeper-sided bowl. Bake the base dish now at 250°F (120°C) for 20 minutes. Bake it right on the oven-safe bowl. Allow it to cool completely. After your "loch" cools, it will pull away from the bowl and can then be easily removed.

5. Roll out your large darker teal ball into a tapered strand, about ⅝ inch (1.5 cm) thick and 8 inches (20 cm) long. Using your crafting blade, cut the strand into three pieces: one for the head and neck (3 inches, or 7.5 cm, long), one for the body (3 inches, or 7.5 cm, long), and one for the tail (2 inches, or 5 cm, long). Shape accordingly (see the photo). Flatten, roll out, and shape your lighter teal ball so that it makes a small, flat oblong piece to use as the chest and throat area of the head and neck. Using the longer eye pin shafts, create small anchor points in the tail and neck pieces by sliding the eye pins up through the blunted bottoms of the cut pieces.

(continued)

Loch Ness Candy Dish · 125

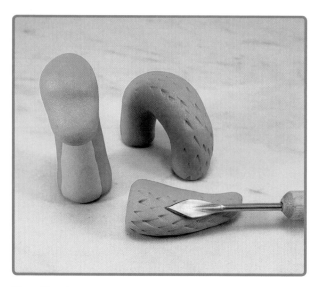

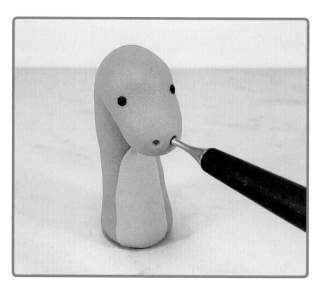

6. Affix the chest and throat piece to the front of the neck. Use your diamond tip tool to create a textured scale-like pattern on the backs of all the pieces of Nessie's body.

7. Use your black clay to create two small disks for the eyes and apply them to the face. Use your small ball stylus to create nostrils in the front of the nose.

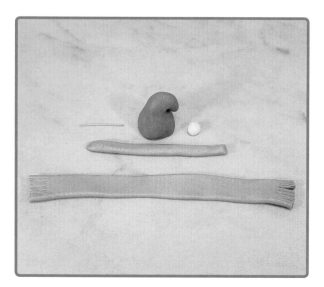

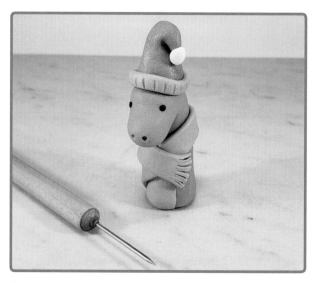

8. Work your dark purple ball into a short cone shape, to resemble a hat. Fold over the tip of the cone. Divide your lighter purple ball into two pieces and roll out each into a short strand, with one being about 3 inches (7.5 cm) long and the other half this length. Only slightly flatten the shorter strand, but fully flatten the larger strand to create a ribbon- or scarf-like shape. Use your craft blade to create fringed ends on the scarf. Roll your white ball into a smooth, round ball.

9. Wrap the scarf around Nessie's neck. Add the hat to the top of the head by pushing the remaining eye pin shaft into the hat, and then use that as a post to anchor the hat to the head. Use a drop of Liquid Sculpey if needed. Use the small strip of lighter purple clay to create a band around the base of the hat. Use your needle tool to create some vertical-line details on the hat band. Add the white pom-pom to the bent tip of the hat, being careful not to distort the shapes.

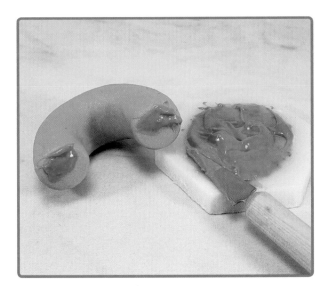

10. Put the remaining blue clay on the parchment paper. Add a small squirt of Liquid Sculpey and use your diamond tip tool to stir the pinches of clay into the liquid clay. Continue until the liquid clay is completely blue. Apply it to the bottoms of Nessie's various pieces that will be touching the dish.

11. Slide the exposed eye pin shafts on the bottom of the neck and tail sections into the dish below. Do not completely pierce the dish; instead, have the rest of the eye pins go up into the body section. Make sure that enough of the blue-tinted Liquid Sculpey is used so that it oozes out around the body pieces as you secure them to the dish, creating a look of Nessie just having crested the water.

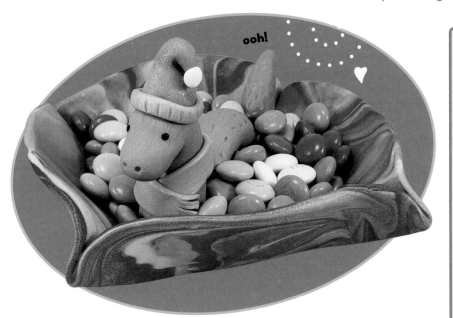

ooh!

12. Bake at 250°F (120°C) for 25 minutes. Allow it to cool completely before adding candy.

VARIATIONS

- Add some other sea creatures.
- Add a small boat.
- Change the color of the hat and scarf, or change the hat style altogether.
- Add small dots of clay along the spine to create a more dragon-like look.
- Use your curved carving tool to etch out an open-mouth shape.

Couch Potato Ornament

Make and bake this appealing little mash-up project and you'll be the envy of all your spuds. If we get started now, you'll be back on the couch, binge-watching your favorite show, in no time!

Project time: 75 minutes

MATERIALS

Potatoes: ⅔ section Jewelry Gold (Sculpey #1132)

Potato spots: 1 B-size piece Hazelnut (Sculpey #1657)

Couch: 3 sections Pearl (Sculpey #1101) completely mixed with ½ section Blue (Sculpey #063)

Couch feet: 1 F-size piece Hazelnut (Sculpey #1657)

TV and remote control: ¼ section Black (Sculpey #042) and 1 F-size piece Silver (Sculpey #1130)

Pillows: 1 E-size piece White (Sculpey #001)

Plant: 1 B-size piece Cactus Green (2 mixed colors; see page 42 for recipe)

Soil: 1 B-size piece Hazelnut (Sculpey #1657)

Pot for plant: 1 C-size piece Sweet Potato (Sculpey #033) completely mixed with 1 F-size piece Pearl (Sculpey #1101)

Rug: 3 sections Gentle Plum (Sculpey #355) completely mixed with ½ section Pearl (Sculpey #1101) for the base color and 1 D-size piece Elephant Gray (Sculpey #1645), 1 D-size piece Black (Sculpey #042), 1 C-size piece Pearl (Sculpey #1101), and 1 C-size piece Silver (Sculpey #1130) for the pattern shapes

Popcorn bucket: 1 E-size piece White (Sculpey #001) and 1 D-size piece Red Pearl (Sculpey #1101)

Popcorn kernels: 1 pinch Lemonade (Sculpey #1150)

Faces: 3 A-size pieces Black (Sculpey #042)

Liquid Sculpey Translucent

3-inch-long (7.5 cm) 16-gauge round wire, for the TV legs

Long eye pin, for the TV legs

¾-inch-long (2 cm) headpin, for the TV antenna

½-inch-long (13 mm) headpin, for the TV antenna

TOOLS

Small ball stylus

Roller

Straightedge or ruler

Craft blade or knife

Long eye pin

8 × 10-inch (20 × 25 cm) piece parchment paper

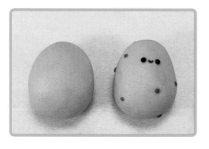

1. Condition your clay to make sure it's pliable and ready to work (see page 12). Roll each piece into a ball. Divide your gold ball into two equal-size pieces and roll them into slightly oblong shapes to resemble small potatoes. Use your small ball stylus to create several small indentations all over the surface of the potatoes. Take your dark brown ball for the potato spots and divide it into several tiny balls. Put those small dots into the indentations you made with the stylus. Use two pinches of the black clay for the faces and affix to the potatoes.

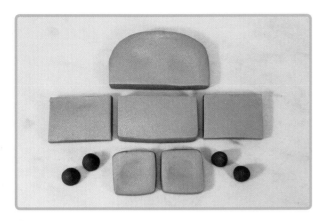

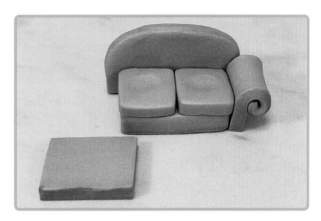

2. Slightly flatten your blue ball. Use your roller to create a flat disk, about ½ inch (13 mm) thick. Use your straightedge and craft blade to square off and divide the disk into six separate pieces: a top-rounded piece for the back of the sofa and a rectangle for the base (both 1 × 2 inches, or 2.5 × 5 cm), two rectangles for the arms (1 × 1½ inches, or 2.5 × 4 cm), and two squares for the seat cushions (1 × 1 inch, or 2.5 × 2.5 cm). Divide your dark brown ball into four-equal size balls for the feet.

3. Assemble your couch, using a few small drops of Liquid Sculpey to securely affix the pieces. Shape the arms by rolling the tops to the outside to create a rounded top. Make sure there are small, shallow indentations on the tops of the cushions for the potatoes to be seated on.

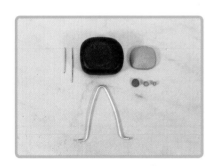

4. Completely mix a small pinch of black clay for the TV with a small pinch of silver clay, and roll it into a ball to be used as the base for the antenna. Take a large pinch of the black clay and set it aside to use as the remote control later. Take two small pinches of the silver clay and roll it into balls for the details on the TV and remote. Form the remainder of your black clay into a slightly flattened and rounded box for the main TV set, and square off and flatten the remainder of your silver clay for the screen. Bend your piece of 16-gauge wire to be the feet for the TV, and use a long eye pin for the third, back leg.

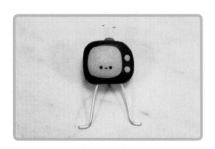

5. Assemble the TV by putting the silver screen on the front of the black box. Add a couple of silver dots on the side to be buttons and knobs. Take your darker piece of silver clay you mixed earlier and use it as the base of your rabbit-ears antenna. Place it on top of the TV. Insert your headpins into the top to complete the antenna effect. Slide the center of the bent wire up through the bottom to create the stand. Use the remaining pinch of black clay to create the face details for the TV screen. Affix them where you think they look best.

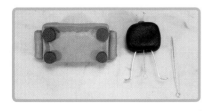

6. Gently turn your blue couch over and use small drops of Liquid Sculpey to affix the four brown feet to the bottom in each corner. Use your long eye pin to add a few drops of Liquid Sculpey up into the opening you made when you slid in the feet for the TV, making sure everything is stable and secure. Use another length of wire to add a second set of feet if necessary.

(continued)

7. Take the small piece of black clay you set aside earlier and form a small rectangle. Use the small dots of silver clay you set aside to create buttons for the top of the rectangle to give it the look of a remote control. Flatten your white ball for the pillows into a rounded rectangle. Use your craft blade to cut the rectangle into two squares and use your straightedge to square up the edges slightly. Round the corners slightly to make them look like pillows.

8. Divide your green ball into four or five pieces of various sizes. Work each piece into a short teardrop shape and flatten slightly. Press the pieces together to create a plant-like or cactus-like effect. Flatten your remaining dark brown ball into a disk. Divide your orange ball into two equal-size pieces. Form one of the pieces into a short, tapered pot. Roll the other out into a long strand and then flatten that strand into a thick strip.

9. Assemble the potted plant by putting the disk of dark brown clay on top of the pot of orange clay. Arrange the green pieces on top of the "soil." Wrap the strip of orange clay around the top rim of the pot to finish the look.

10. Divide your white ball for the popcorn bucket into two pieces, one twice as large as the other, setting the small piece aside for the popcorn later. Flatten and roll out the larger piece until quite thin and in the rough shape of a disk. Divide your red ball into seven pinches and roll out those pinches into long, thin strands. Place these strands on top of the white disk in parallel lines. Use your roller to flatten the red clay to create a smooth surface. Take the remaining white clay and divide it into several small, rough ball shapes. Do the same with your yellow clay. Gently mix some together to form the popcorn kernels.

11. Roll up the white and red clay disk into a bucket shape. Place your popcorn inside the bucket. Use your small ball stylus to position the kernels and create the right texture and mix between the white and yellow to simulate buttered popcorn in the bucket.

12. On top of your piece of parchment paper, roll out your purple ball until it's about ¼ inch (6 mm) thick. Take the small pieces of gray, silver, pearl, and black clay, and cut them into several equal-size pieces. Create small shapes, such as circles, semicircles, triangles, etc., from each. Place these shapes on top of the large purple disk, either randomly or in a pattern—however you think they look best.

13. Use your roller to firmly press the pattern into the purple disk. Use your craft blade to trim the edges of the rug as you see fit. Leave the disk on the parchment paper.

14. Move your parchment paper and rug onto your baking tray. Assemble your scene as you think it looks best. Use Liquid Sculpey to affix the elements securely, especially the feet of the TV, which you should also slightly press into the rug.

15. Once the scene is fully assembled, carefully move the tray to your oven and bake at 250°F (120°C) for 40 minutes, rotating the tray halfway through. Allow it to cool completely.

VARIATIONS

• Change colors and patterns.

• Add a pet or change the snacks.

• Put a logo on the TV screen.

• Add a tiny baby potato.

• Give them drinks!

amazing!

S'mores Campfire Scene

This hot, little project might look like you'll be roughing it, but it's actually as simple as falling off a log. Stick with me and it'll come out really sweet. Let's get this thing lit!

Project time: 75 minutes

MATERIALS

Logs and stump: 2 sections Hazelnut (Sculpey #1657) completely mixed with ½ section Tan (Sculpey #301) and ½ section Tan (Sculpey #301) unmixed

Fire: 1 F-size piece Sweet Potato (Sculpey #033) folded and gently mixed with 1 F-size piece Deep Red Pearl (Sculpey #1140) (don't overmix)

Chocolate bars: 2½ sections Hazelnut (Sculpey #1657)

Graham Crackers: 2 sections Jewelry Gold (Sculpey #1132)

Marshmallows: ½ section Pearl (Sculpey #1101) completely mixed with ½ section White (Sculpey #001)

Stones: 1½ sections Elephant Gray (Sculpey #1645)

Faces: 2 A-size pieces Black (Sculpey #042)

1 flameless votive candle

Liquid Sculpey Translucent

Two 2-inch-long (5 cm) 16-gauge round wires, for the marshmallow roasting sticks

1 small round of wood or a ceramic tile, for the base

Craft glue (E6000 brand or similar)

TOOLS

Large ball stylus

Needle tool

8 x 10-inch (20 x 25 cm) piece parchment paper

Roller

Craft blade or knife (or optionally, square and rectangular cookie cutters)

Chisel tip shaper

Small ball stylus

Toothbrush

Straightedge or ruler

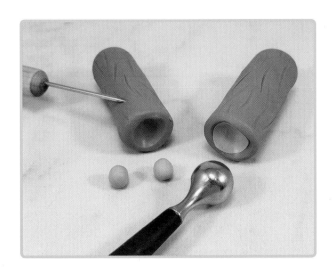

1. Condition your clay to make sure it's pliable and ready to work (see page 12). Roll each piece into a ball. Divide your light brown ball into three large equal-size pieces (⅔ section each) and four small equal-size pieces (⅛ section each). Set one of the large pieces and all of the small pieces aside. Take the remaining two large pieces and roll them into log shapes, each 2 inches (5 cm) long. Take four pinches of your tan ball and form rough balls. Flatten these into disks. Use your large ball stylus to press out a shallow indentation on the ends of each log. Press the disks of tan clay into the indentations on the ends, smoothing them out with your stylus. Use your needle tool to create a bark-like texture on the outside of the logs.

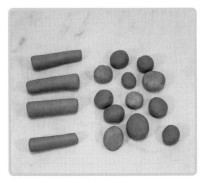

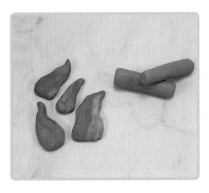

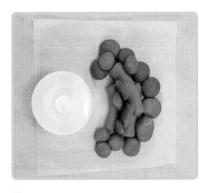

2. Take the four small pieces of light brown clay you set aside earlier and shape them into small logs. Use your needle tool to create the bark texture on those as well. Divide your gray ball into several small balls. Shape and smooth them until they look like round stones.

3. Divide your marbled orange ball into several pieces of various sizes. Work the pieces into different shapes to simulate rising flames. Use the small logs as a reference for size because they'll be placed together to make the campfire.

4. On top of your piece of parchment paper, place your stones, small logs, and flames in a semicircular campfire scene. Make sure to leave room in the center for a flameless votive candle. You can even arrange the pieces around the tea light to get it just right.

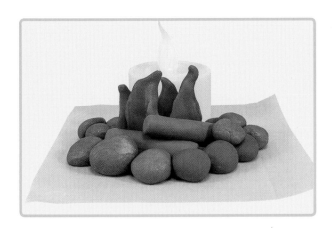

5. Check the look of the campfire from all angles, but especially from the front. Ensure you'll be able to see the votive behind your fire and log pieces. Once it looks the way you want, remove the votive if you used it for positioning, and then secure the clay pieces by adding small drops of Liquid Sculpey and pressing them together. Leave the scene on the parchment paper.

(continued)

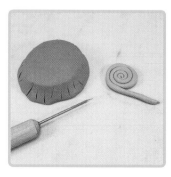

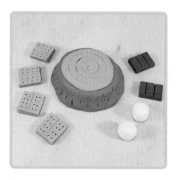

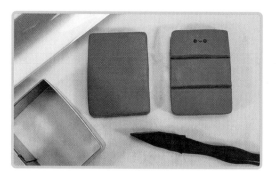

6. Flatten your remaining piece of light brown clay into a squat, tapered cone with a flat top for a tree stump. Use your needle tool to create a bark-like texture, just like you did earlier with the logs. Take your remaining piece of tan clay and roll it out into a strand, about 6 inches (15 cm) long. Roll the strand up onto itself to create a spiral disk.

7. Use your roller to flatten the spiral of tan clay you just made. Affix it to the top of the stump, making sure it's secure. Make some mini chocolate bars, graham crackers, and marshmallows following the instructions in the S'mores Charm project (page 44).

8. Pinch off two small pieces of your dark brown clay to use as arms in step 12. Take your remaining large piece of dark brown clay, and using your craft blade or a cookie cutter, create a rectangle, about 1 x 2 inches (2.5 x 5 cm). Use your roller and press lightly against your work surface to make the top and bottom, keeping it about ¼ inch (6 mm) thick. Use your chisel tip shaper to etch lines into the surface, about half the depth of the bar, making it look like a larger version of the chocolate bars you made earlier. Use a pinch of the black clay to make the face details and place them on the bar where you think they look best.

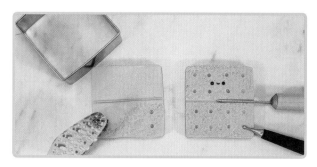

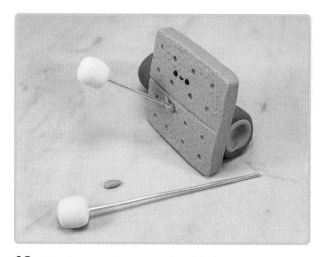

9. Pinch off two small pieces of your gold clay and set aside to use as small arms in step 10. Take the remaining gold clay and use your craft blade or a square cookie cutter to create a large square, about 2 x 2 inches (5 x 5 cm). Slightly flatten the square with your roller until it's about ¼ inch (6 mm) thick. Use your craft blade to trim and shape the edges. Using your needle tool, etch a shallow line across the center of the cracker. Use your small ball stylus to create a regular pattern of indentations across the surface. Use your toothbrush to create the texture of a graham cracker. Use the remaining black clay to make the face details and place them on the front of the cracker where you think they look best.

10. Use the small pieces of gold clay you set aside earlier and form two small arms that are slightly tapered in shape. Take one of the small marshmallows you made earlier and place it on an end of one of the pieces of wire. Place one of your large logs behind your large graham cracker. Press the wire with the marshmallow through the cracker and into the log behind it, leaving a length of wire and the marshmallow exposed.

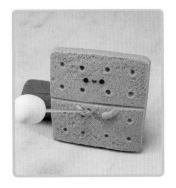

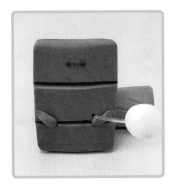

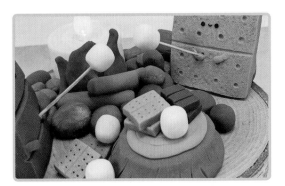

11. Place the two small arms on the surface of the cracker, wrapping one of them around a wire so it looks like it's holding a stick for roasting marshmallows over an open fire. Make any adjustments to ensure it's all securely affixed and stable.

12. Repeat steps 10 and 11 with the large chocolate bar, again making sure the whole piece is securely affixed and stable.

13. Move your campfire and the parchment over to a baking tray. Assemble the whole scene with the stones; mini graham crackers, chocolate bars, and marshmallows; campfire; and main characters together. Use a few drops of Liquid Sculpey to ensure that most of the pieces are securely affixed to one another. Before baking, double-check to make sure the scene will fit on the base that you've chosen and that you've left room for the votive candle. Not every piece has to be attached to each other now as you'll be gluing the entire scene to the base after you bake it.

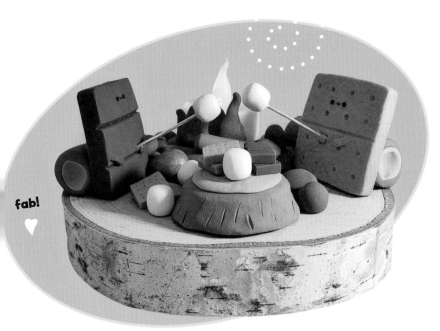

fab!
♥

VARIATIONS

- Lightly mix a tiny bit of brown clay into the marshmallows on the sticks to simulate them being toasted.

- Add a few other characters to the scene, like snails or turtles munching on a dropped marshmallow or graham cracker.

- Change face details, like adding an open mouth and tongue on one of the characters.

14. Carefully move the tray to your oven and bake at 250°F (120°C) for 35 minutes. Keep an eye on it to make sure the white clay doesn't darken. Allow to cool completely. Carefully move the completed piece onto the base you've chosen, and use some craft glue to secure it to the surface. Allow the glue to dry and cure completely before use. Add the flameless votive to complete the scene.

1. Condition your clay to make sure it's pliable and ready to work (see page 12). Roll each piece into a ball. Flatten your marbled teal clay into a disk. Using your roller, roll the clay out approximately 1/16 inch (1.5 mm) thick, making sure it's big enough to fill your oven-safe dish. Smooth the edges. Lay inside the dish and make sure the bottom is flat.

Octopus Jewelry Holder

This cute jewelry holder might look complicated, but you won't need eight hands to make it. It's going to go swimmingly.

Project time: 75 minutes

MATERIALS

Ocean Base: 1 section Teal Pearl (Sculpey #538) lightly mixed and folded with 3 sections Pearl (Sculpey #1101) to create a marbled, sea-like look

Octopus body: 1 section Purple (Sculpey #513) completely mixed with 1 brick Pearl (Sculpey #1101)

Octopus tongue: 1 A-size piece Princess Pearl (Sculpey #530)

Octopus spots and shell: 1 E-size piece Pearl (Sculpey #1101)

Starfish: 1 F-size piece Sweet Potato (Sculpey #033)

Eyes: 2 A-size pieces Black (Sculpey #042)

Liquid Sculpey Translucent

1½-inch-long (4 cm) eye pin shafts, for support

1 Ice Cream Charm without the eye pin (page 46)

TOOLS

Roller

Large ball stylus

5½-inch (14 cm) oven-safe round dish, plate, or saucer

Wedge tip tool

Long eye pin

Small ball stylus

Small star-shaped cutter

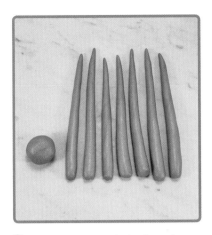

2. Take your purple ball and pinch off eight equal-size pieces, using about two-thirds of the clay. Roll those pieces into 2- to 3-inch-long (5 to 7.5 cm) tapered strands for the arms.

3. With the remaining purple clay, first pinch off a small piece to be used as the spots on the octopus' head later, and then shape the rest of the clay into a bell shape as the body. Use your large ball stylus to create a deep indentation in the underside of the bell shape.

4. Tuck the thicker ends of the eight arms inside the bell shape, leaving the tapered ends hanging out. Smooth the body into the arms, contouring and shaping it to create a defined head and body.

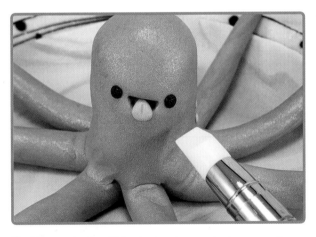

5. Carefully place the octopus in the center of your dish and evenly spread the arms out from the center, leaving spaces on the base to hold the jewelry later.

6. Use a pinch of black clay to create two small disks for the eyes of the octopus and affix them to the head. Use your wedge tip tool to make the indentation for the mouth. Shape your pink ball into a flat teardrop shape for the tongue. Use your long eye pin to press a small indentation in the center of it. Use a small drop of Liquid Sculpey to affix the tongue inside the mouth. Completely mix a tiny pinch of pearl clay with the small pinch of purple clay you set aside earlier. Divide it into 3 or 4 balls and slightly flatten them into small disks. Add as spots to the octopus' head and body.

(continued)

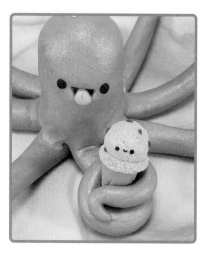

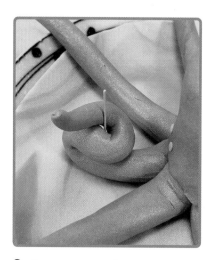

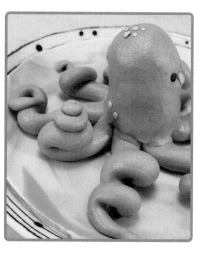

7. Tightly curl one arm around your Ice Cream Charm, arranging it close to the octopus's tongue but with enough space to be able to slide a ring on the cone. Use a drop or two of Liquid Sculpey, if necessary, to keep the cone securely affixed.

8. For any arms that you want to curl up, or for more complex or intricate configurations of the arms, use an eye pin shaft as a support to mold and wrap the arms around.

9. Arrange the rest of the arms however you would like, making sure to leave plenty of spaces to hold different kinds of jewelry.

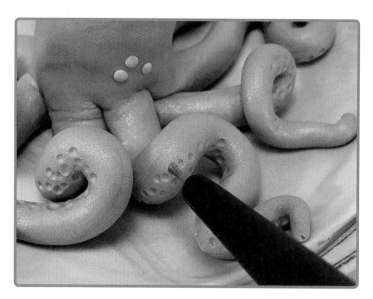

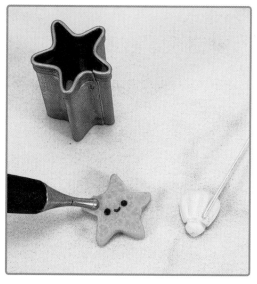

10. Using the small ball stylus, create a pattern of small indentations on the underside of each leg to simulate the suckers on the bottoms of octopus arms.

11. Using the remaining pearl clay, create a tiny seashell shape. Use a long eye pin to add vertical-line details. Flatten the orange ball and use the star-shaped cutter to cut out a star shape. Use the small ball stylus to create the starfish-like texture on top. Use the remaining black clay to create a short line for the mouth and disks for the eyes. Apply the face to the starfish.

VARIATIONS

- Change the face details.
- Change the color of the octopus or add colors to the underside of it.
- Add more sea creatures.
- Add some clay initials to give it a personal monogram.
- Modify it to hold pens, incense sticks, or votive candles.

12. Arrange the various pieces on the dish until it looks the way you want, moving the arms accordingly. The dish will slightly shrink during baking, so don't put anything too close to the rim.

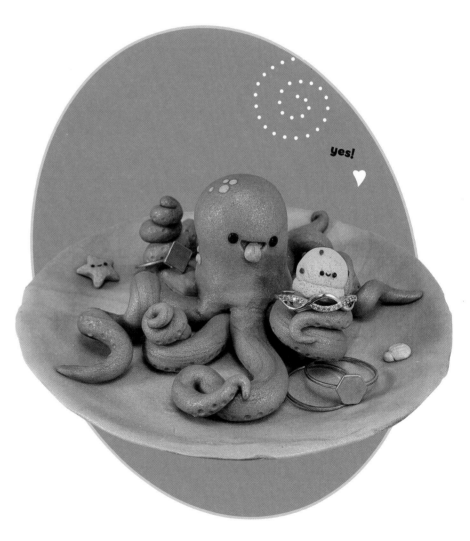

yes!

13. Apply Liquid Sculpey to the underside of the arms in a few spots to secure them to the base. Add the starfish and shell with Liquid Sculpey.

14. Bake at 275°F (135°C) for 40 minutes, rotating the dish halfway through. Let cool completely in the dish before removing and using.

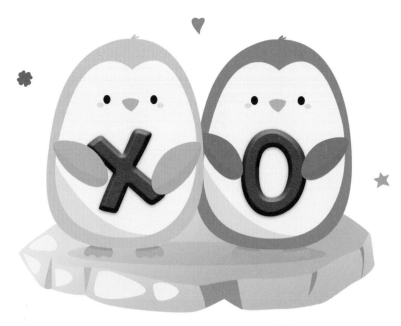

Penguin Tic-Tac-Toe Game

This cool project will let everyone know that you are in it to penguin it! It's got quite a few pieces, but if you just follow the steps, you can't lose. Let's waddle in and get started, shall we?

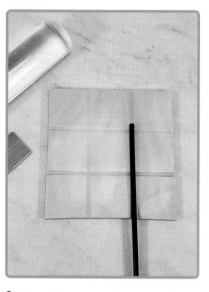

1. Condition your clay to make sure it's pliable and ready to work (see page 12). Roll each piece into a ball. Using your roller, roll out your marbled teal clay into an ⅛-inch-thick (3 mm) square about 4½ inches (11 cm) long on each side. Use your straightedge and craft blade to trim the edges to create a 4 × 4-inch (10 × 10 cm) square. Use the thin plastic stirrer to create indentations for an even and regular 3 × 3-grid pattern on the surface.

Project time: 60 minutes

MATERIALS

Ice grid: 1 section Teal (Sculpey #538) lightly mixed and folded with 2 sections Pearl (Sculpey #1101) to create a marbled, icy effect

White base and ice block rim: 2½ bricks White (Sculpey #001)

Xs and Os: ½ section Silver (Sculpey #1130), divided in half

Purple penguins: 1 F-size piece Purple (Sculpey #513) completely mixed with 1½ sections Pearl (Sculpey #1101)

Penguin tummies: ½ section Pearl (Sculpey #1101), divided in half

Penguin feet and beaks: 1 D-size piece Sweet Potato (Sculpey #033), divided in half

Pink penguins: 1 F-size piece Fuchsia (Sculpey #1112) completely mixed with 1½ sections Pearl (Sculpey #1101)

Eyes: 1 B-size piece Black (Sculpey #042)

Liquid Sculpey Pearl

TOOLS

Roller

Straightedge or ruler

Craft blade or knife

Thin plastic stirrer

Thick plastic drinking straw

Chisel tip shaper

3. Roll the remaining piece of white clay into a thick strand, about 22 inches (56 cm) long and ½ inch (5 cm) wide and thick. Press the strand gently against your work surface on all four sides to create a square-shaped rod. Cut the rod into a series of 22 equal-size bricks.

2. Divide the white ball into two equal-size pieces. Set one piece aside. Roll out the other piece into a rough rectangle about ⅛ inch (3 mm) thick. Use your straightedge and craft blade to trim the edges to create a smooth and straight rectangle, about 6 × 5 inches (15 × 13 cm). Lay your grid piece on top of the white base, leaving more room on the sides than on the top and bottom. Make sure the grid piece is centered, and then secure it to the white base with a few drops of Liquid Sculpey.

4. Use your straightedge and craft blade to trim the edges of the bricks to square them up and make small rectangular ice block shapes.

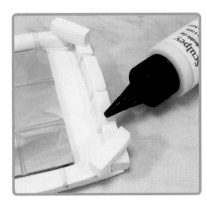

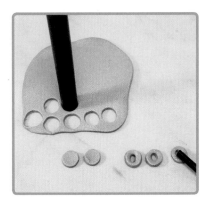

5. Place the white rectangular blocks on the edges of the white base. Make sure they all fit together the way you want.

6. Use a few drops of Liquid Sculpey on each block, and build your final pattern for the ice blocks around the teal grid surface. Be sure to leave room for your penguin players to hang out on the sidelines later.

7. Roll out half of the silver clay into a thin sheet, about ⅛ inch (3 mm) thick. Use your thick straw to cut out five letter *O* shapes, and then cut out their centers with the thin stirrer.

(continued)

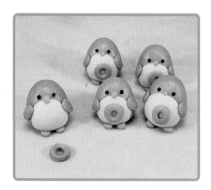 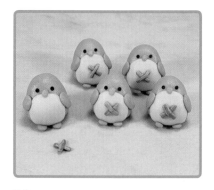

8. Use the purple and half each of the pearl, orange, and black clay to make five purple penguins (following the instructions on page 38). Add the silver Os to their tummies after you've finished making them.

9. Take the remaining half of silver clay and roll it out to the same thickness you did for making the Os. Use your craft blade to cut small, thin strips and then cross those strips to create five small Xs.

10. Use the fuchsia and the remaining pearl, orange, and black clay to make five pink penguins (following the instructions on page 38). Add the silver Xs to their tummies after you've finished making them.

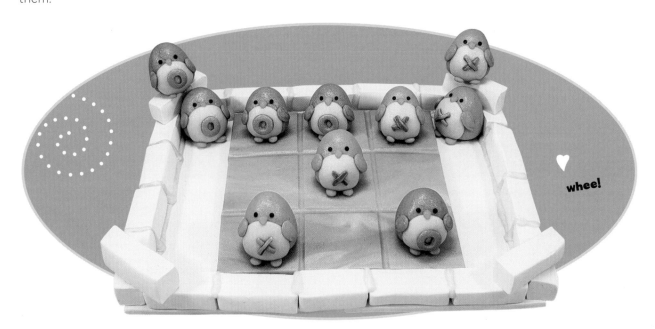

whee!

11. Bake the base at 250°F (120°C) for 20 minutes. Bake the penguins at 275°F (135°C) for 15 minutes. Allow all pieces to cool completely before use.

VARIATIONS

- Add some spectators, like a whale or narwhal poking up through the ice.
- Change the colors.
- Create a bigger board for checkers with white-and-blue ice squares in the grid.
- Create a scoring system on the side with pins to slide into scoring holes.

ACKNOWLEDGMENTS

My deep and heartfelt thanks to the following people . . .

My husband, Trevor. My partner. My best friend.
My favorite. I'm with you.

Both our parents, Penny and Mike and Lynn and Gerry,
for all your support and encouragement.

Our friends: To Mary, whose beautiful photographs are
the backbone of this book. Your hard work, talents, and
strength are so inspiring. To Jonas, for your friendship
and example. You helped show me the way. And to
Taylore, for your energy, loyalty, and always picking up
the slack when I needed it. Love you all!

And finally, a special shout-out to Coffee,
without whom none of this would have been possible.

About the Author

DANI BANANI is a mixed-media artist, maker, and entrepreneur based in the Pacific Northwest. Born and raised in small-town Nebraska, Dani developed her passions for art and music early on, learning multiple musical instruments and working in different visual arts and media. After completing school, Dani moved West, where she spent a decade working a variety of retail and corporate design jobs, refining her skills and developing her own style.

Five years ago, she decided to strike out on her own with a variety of kawaii-style stationery products and a line of handmade polymer clay plant holders. During this time, Dani has developed her brand, Funusual Suspects, into one of the top shops on Etsy with over three hundred products, and her work has been featured on BuzzFeed, *House Beautiful*, *Popular Science*, the *Seattle Times*, the *Pickler & Ben* show, the D!NG YouTube channel, and Hive Handmade, among many other online and media sources.

She shares a creative and hectic life with her husband, Trevor, her dog, Absa, and her cat, Professor Moriarty. This is her first book.

FUNUSUAL SUSPECTS

Dani Banani